Christmas, children, is not a date.
It is a state of mind.

Mary Ellen Chase

Christmas!
'Tis the season for kindling the fire of hospitality in
the hall, the genial fire of charity in the heart.

Washington Irving

BELIEVE

CHRISTMAS TREASURY

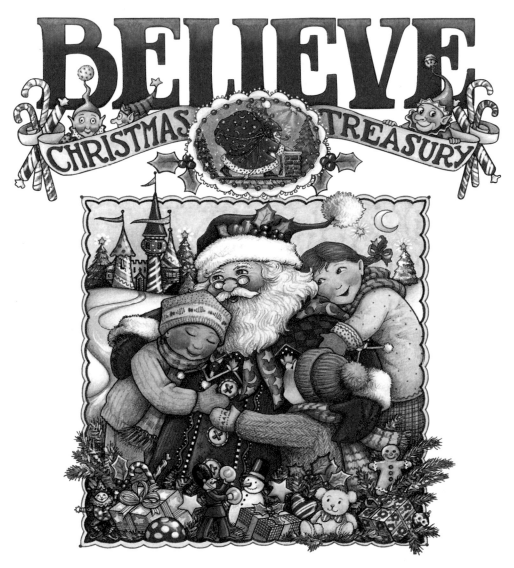

Illustrated by Mary Engelbreit

**Andrews McMeel
Publishing**

Kansas City

www.andrewsmcmeel.com

is a registered trademark of Mary Engelbreit Enterprises, Inc.

00 01 02 MON 10 9 8 7 6 5 4 3

Library of Congress Cataloging-in-Publication Data

Engelbreit, Mary.
 Believe : A Christmas treasury / illustrated by Mary Engelbreit.
 p. cm.
 Includes index.
 ISBN 0-8362-6762-1 (hd)
 1. Christmas--Quotations, maxims, etc. 2. Christmas--Literary
collections. I. Title.
PN6084.C52E54 1998
263'.915--dc21 98-7791
 CIP

ATTENTION: SCHOOLS AND BUSINESSES
Andrews McMeel books are available at quantity discounts with bulk purchase for educational,
business, or sales promotional use. For information, please write to: Special Sales Department,
Andrews McMeel Publishing, 4520 Main Street, Kansas City, Missouri 64111.

Contents

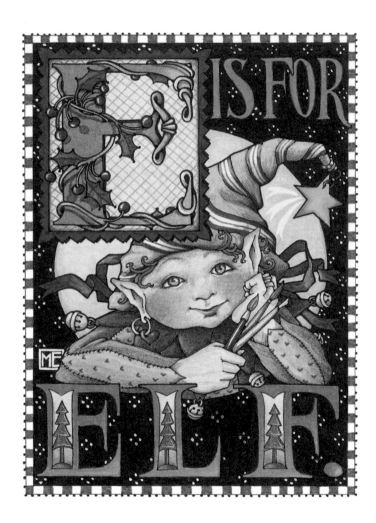

E IS FOR
ELF.

ILLUSTRATIONS

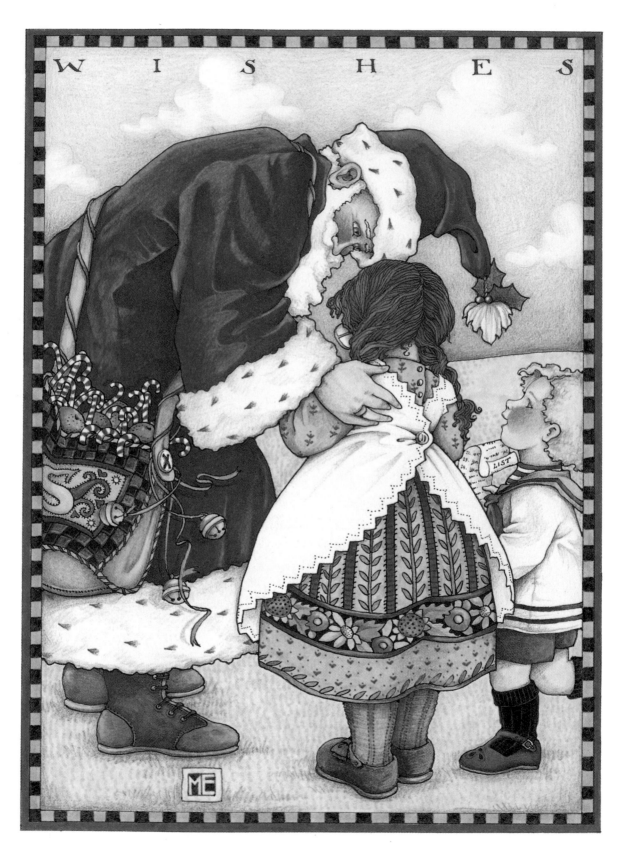

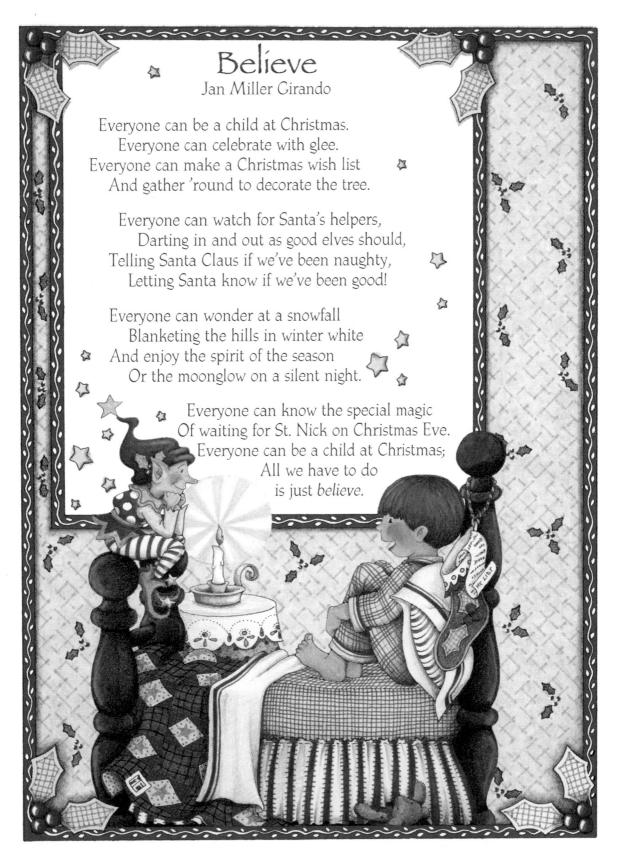

Believe
Jan Miller Girando

Everyone can be a child at Christmas.
Everyone can celebrate with glee.
Everyone can make a Christmas wish list
And gather 'round to decorate the tree.

Everyone can watch for Santa's helpers,
Darting in and out as good elves should,
Telling Santa Claus if we've been naughty,
Letting Santa know if we've been good!

Everyone can wonder at a snowfall
Blanketing the hills in winter white
And enjoy the spirit of the season
Or the moonglow on a silent night.

Everyone can know the special magic
Of waiting for St. Nick on Christmas Eve.
Everyone can be a child at Christmas;
All we have to do
is just *believe*.

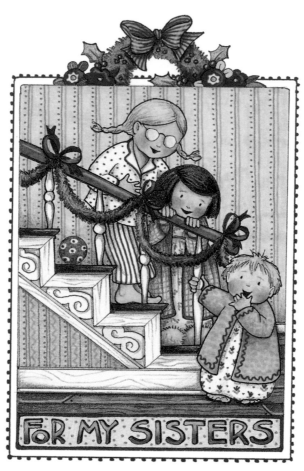

FOR MY SISTERS

ALEXA & PEGGY

who were with me
at the
crack of dawn
on all those
Christmas
mornings

❧ Introduction ❧

I'm sure this will come as a great shock to you, but Christmas is my favorite holiday! It's the one time of year when I can completely indulge my decorating instincts and let loose with all of my knickknacks and collectibles to create a haven of holiday spirit. Every decoration and ornament has a story, and stories are what make Christmas so special for me. Every year, as we go about making the house look as magical as we can, we reconnect to our past in a direct, intimate way; when we hold an ornament, we are touching the past. We also reconnect through our traditions and rituals, the music that we play, the songs we sing, the stories that we read and tell. And as we live each moment of the new sea-

son, we are creating new stories and traditions for the next generation.

When I started drawing, it was because I wanted to illustrate books the way my favorite artists did. I loved to read and I loved to draw, and I dreamed of some day being able to illustrate my favorite stories.

Over the years, I kept the books my mother and grandmother gave to me that inspired me to start drawing. I also saved the books that I had growing up that had stories that I wanted to illustrate. Many of these were Christmas collections of stories, poems, carols, and quotes. I never tired of the collections that I first read as a child, and along the way, I've picked up new ones. The pieces in this collection stand out to me because they capture what is special about this most wonderful holiday; a holiday that brings us together as none other, that encourages us to look back, and re-energizes us to move forward another year.

The opportunity to share with you my favorite Christmas literature is a dream come true. They have been a part of my family's Christmas traditions for quite some time, and I hope you enjoy them enough to make them part of yours.

Mary Engelbreit

A Christmas Carol

Christina Rossetti

In the bleak mid-winter
Frosty wind made moan,
Earth stood hard as iron,
Water like a stone;
Snow had fallen, snow on snow,
Snow on snow,
In the bleak mid-winter
Long ago.

Our God, Heaven cannot hold Him
Nor earth sustain;
Heaven and earth shall flee away
When He comes to reign:
In the bleak mid-winter
A stable-place sufficed
The Lord God Almighty
Jesus Christ.

Enough for Him, whom cherubim
Worship night and day,
A breastful of milk
And a mangerful of hay;
Enough for Him, whom angels
Fall down before,
The ox and ass and camel
Which adore.

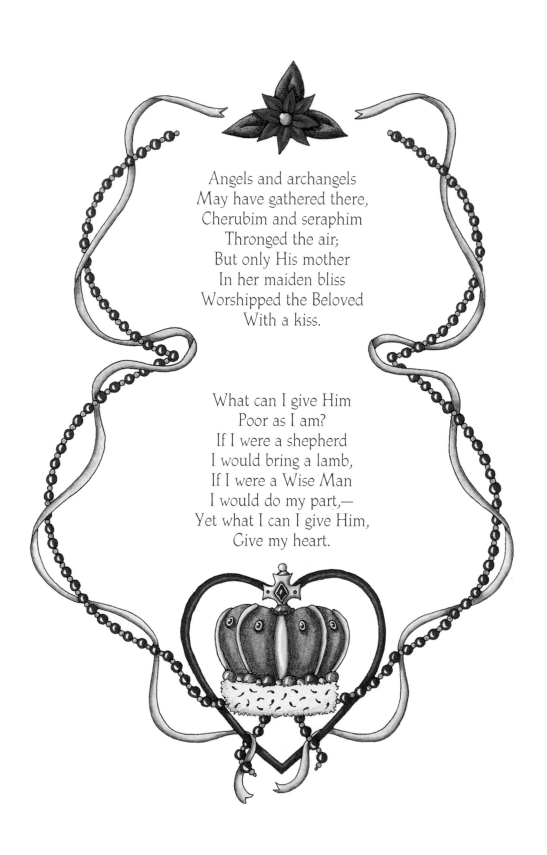

Angels and archangels
May have gathered there,
Cherubim and seraphim
Thronged the air;
But only His mother
In her maiden bliss
Worshipped the Beloved
With a kiss.

What can I give Him
Poor as I am?
If I were a shepherd
I would bring a lamb,
If I were a Wise Man
I would do my part,—
Yet what I can I give Him,
Give my heart.

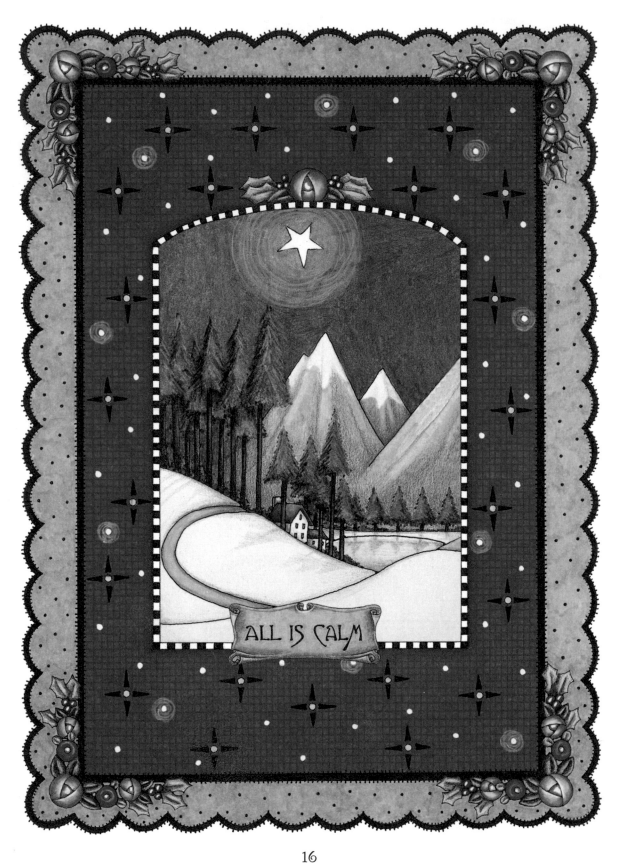

ALL IS CALM

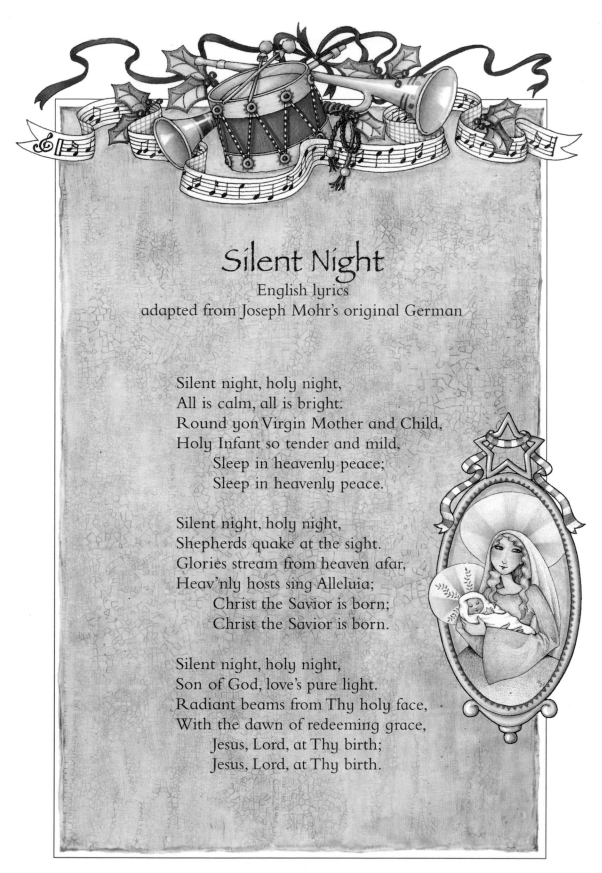

Silent Night

English lyrics
adapted from Joseph Mohr's original German

Silent night, holy night,
All is calm, all is bright:
Round yon Virgin Mother and Child,
Holy Infant so tender and mild,
Sleep in heavenly peace;
Sleep in heavenly peace.

Silent night, holy night,
Shepherds quake at the sight.
Glories stream from heaven afar,
Heav'nly hosts sing Alleluia;
Christ the Savior is born;
Christ the Savior is born.

Silent night, holy night,
Son of God, love's pure light.
Radiant beams from Thy holy face,
With the dawn of redeeming grace,
Jesus, Lord, at Thy birth;
Jesus, Lord, at Thy birth.

Dear Editor,

I am 8 years old. Some of my friends say there is no Santa Claus. Papa says if you see it in the Sun, it is so. Please tell me the truth, is there a Santa Claus?

Virginia O'Hanlon

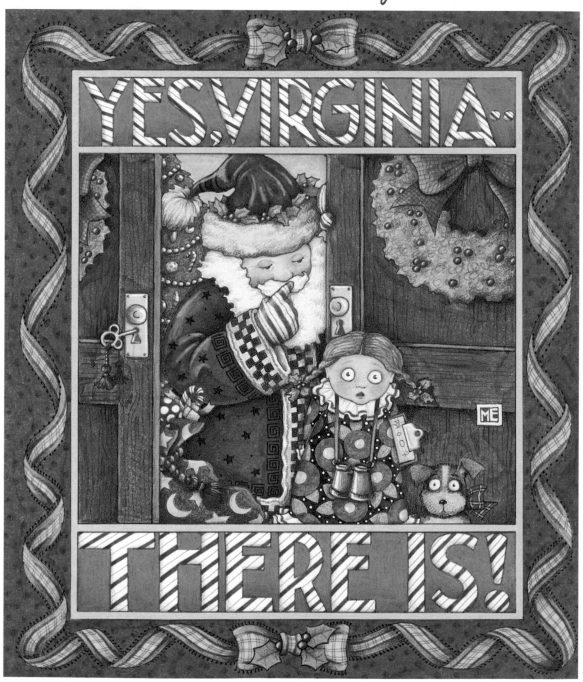

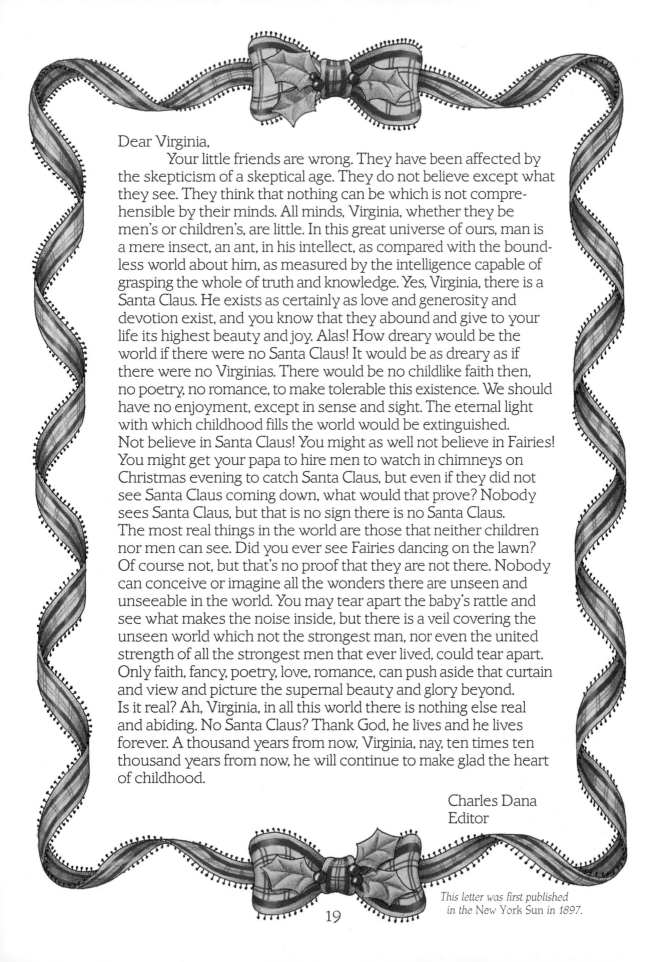

Dear Virginia,

 Your little friends are wrong. They have been affected by the skepticism of a skeptical age. They do not believe except what they see. They think that nothing can be which is not comprehensible by their minds. All minds, Virginia, whether they be men's or children's, are little. In this great universe of ours, man is a mere insect, an ant, in his intellect, as compared with the boundless world about him, as measured by the intelligence capable of grasping the whole of truth and knowledge. Yes, Virginia, there is a Santa Claus. He exists as certainly as love and generosity and devotion exist, and you know that they abound and give to your life its highest beauty and joy. Alas! How dreary would be the world if there were no Santa Claus! It would be as dreary as if there were no Virginias. There would be no childlike faith then, no poetry, no romance, to make tolerable this existence. We should have no enjoyment, except in sense and sight. The eternal light with which childhood fills the world would be extinguished. Not believe in Santa Claus! You might as well not believe in Fairies! You might get your papa to hire men to watch in chimneys on Christmas evening to catch Santa Claus, but even if they did not see Santa Claus coming down, what would that prove? Nobody sees Santa Claus, but that is no sign there is no Santa Claus. The most real things in the world are those that neither children nor men can see. Did you ever see Fairies dancing on the lawn? Of course not, but that's no proof that they are not there. Nobody can conceive or imagine all the wonders there are unseen and unseeable in the world. You may tear apart the baby's rattle and see what makes the noise inside, but there is a veil covering the unseen world which not the strongest man, nor even the united strength of all the strongest men that ever lived, could tear apart. Only faith, fancy, poetry, love, romance, can push aside that curtain and view and picture the supernal beauty and glory beyond. Is it real? Ah, Virginia, in all this world there is nothing else real and abiding. No Santa Claus? Thank God, he lives and he lives forever. A thousand years from now, Virginia, nay, ten times ten thousand years from now, he will continue to make glad the heart of childhood.

Charles Dana
Editor

This letter was first published in the New York Sun *in 1897.*

Keeping Christmas: The Magical Message of Santa

Jan Miller Girando

One day Santa's helpers,
 the fairies and elves,
who were playfully making
 some mischief themselves,
heard St. Nicholas call—
 "I need help! Here's my list.
Go make certain no good girls
 and boys have been missed!"
Santa's helpers took off,
 hiding here, hiding there,
flitting inside and out,
 all about, everywhere!

Though the fairies and elves
 darted to, darted fro,
scrambled over and under,
 up high and down low,
they could never be seen,
 never once, never twice,
 by the girls, by the boys,
 by the dogs, cats, and mice
who were trying their best
 now that Christmas was here
 to impress Santa Claus
with good deeds, and good cheer.

And impressing St. Nick wasn't easy at all,
 thought a few worried children.
Would Santa recall
every good little, kind little, sweet little tyke
 who deserved a red wagon,
 a doll, or a bike?
Soon the children were squabbling.
They started to boast
 about who could be nicest . . .
 act kindest . . . do most.

They had no indication
 the elves were around,
 or that fairies were watching,
 not making a sound.
They just knew Santa Claus
 would soon pack up his sleigh,
 and they had to make sure
 he'd be coming their way!

One delightful young fellow
 in pj's of blue
 thought he'd been extra good
 and he hoped Santa knew!
"If only the elves
 and the fairies could see
 just how *special* I am
 and how *nice* I can be!

I would never throw food
 or put beans up my nose
 and pretend I'm a walrus
 in little-boy clothes!
I can play well with others!
 I give and I share!
I'm the very best boy
 to be found anywhere!"

Then a bossy young lady
 stepped forward to say,
 "Santa's elves will miss out
 if they don't look my way!
I am sweeter than candy
 and nicer than pie.
I'm an angel with wings
 and a halo—no lie!
I am gentle and loving.
 I don't cry or pout.
(And if you think I'm kidding,
 you'd better watch out!)"

So the contest continued
 right down to the night
Santa packed up his sleigh,
 hitched reindeer for flight.
Little children who'd been
 sort of naughty all year
 tried to clean up their act
as the big day drew near!

All the while, Santa watched.
 Then he frowned at his elves.
 "Don't those boys and girls know
 they're just fooling themselves
if they try to be good
 just when Christmas is here
 and impress a few people
 a few weeks each year?
Go and give them a hint,
 a direction, a clue!
It's not quite Christmas yet . . .
 see if you can get through!"

Santa scowled,
　　　　and the elves,
just as quick as could be,
　　　　jumped and scampered away.
There were children to see!

They took off like a flash—
　　　　there was lots to be done!
Time to spread the good news:
　　　　being nice could be *fun!*
Though they'd never been seen,
　　　　never once,
　　　　　　　　never twice,
it was to time to come forward
　　　　with Santa's advice.

And then, in a twinkling,
　　　　the wondering eyes
of enchanted believers
　　　　got quite a surprise!
In a blink, in a wink,
　　　　there were elves everywhere!
Fairies perched on the mantle,
　　　　the bedpost, the chair.
Down the stairway they tumbled.
　　　　They marched up the walk.
But the best part began
　　　　when they started to *talk!*

"Santa knows what you're up to,"
 they shouted with zest
to the boys and the girls
 who were doing their best
 to make up for lost time.
"We are here as a sign.
 If you change your ways quickly,
you're sure to do fine!"

"Those who give to get noticed,"
 the tiny elves said,
"are not giving at all,
 but are *taking*, instead!
They're just out to impress,
 not to do a good deed.
They are piggy and rude,"
 Santa's fairies agreed.

"But those sweet little children
 who try to be good,
who are happy and pleasant,
 and do what they should,
never have to be worried
 as Christmas appears . . .
never have to do extra
 as Christmas Eve nears.
Santa's penciled their names
 at the top of his list,
and there's simply no way
 kids like that would be missed!"

One by one,
 all the children
 the elves stopped to see
 heard the word.
One by one,
 they began to agree.

And with that, the elves cheered!
 Now their mission was done!
Santa's message was out!
 It was time to have fun!
"We've accomplished our task
 and helped children do right,"
they exclaimed with great glee
 while parading from sight.

And since that very day,
 boys and girls have been *nice*,
and the elves haven't been seen.
 Never once . . .
 never twice.

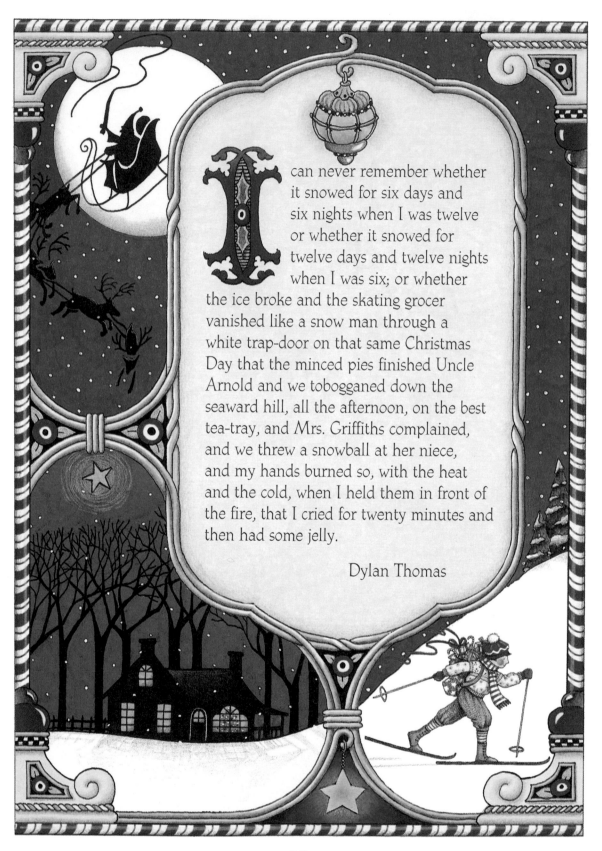

I can never remember whether it snowed for six days and six nights when I was twelve or whether it snowed for twelve days and twelve nights when I was six; or whether the ice broke and the skating grocer vanished like a snow man through a white trap-door on that same Christmas Day that the minced pies finished Uncle Arnold and we tobogganed down the seaward hill, all the afternoon, on the best tea-tray, and Mrs. Griffiths complained, and we threw a snowball at her niece, and my hands burned so, with the heat and the cold, when I held them in front of the fire, that I cried for twenty minutes and then had some jelly.

Dylan Thomas

Home for Christmas

Elizabeth Bowen

This is meeting-time again. Home is the magnet. The winter land roars and hums with the eager speed of return journeys. The dark is noisy and bright with late-night arrivals—doors thrown open, running shadows on snow, open arms, kisses, voices and laughter, laughter at everything and nothing. Inarticulate, giddying and confused are those original minutes of being back again. The very familiarity of everything acts like shock. Contentment has to be drawn in slowly, steadyingly, in deep breaths—there is so much of it. We rely on home not to change, and it does not, wherefore we give thanks. Again Christmas: abiding point of return. Set apart by its mystery, mood and magic, the season seems in a way to stand outside time. All that is dear, that is lasting, renews its hold on us: we are home again. . . .

This glow of Christmas, has it not in it also the gold of a harvest? "They shall return with joy, bringing their sheaves with them." To the festival, to each other, we bring in wealth. More to tell, more to understand, more to share. Each we have garnered in yet another year; to be glad, to celebrate to the full, we are come together. How akin we are to each other, how speechlessly dear and one in the fundamentals of being, Christmas shows us. No other time grants us, quite, this vision—round the tree or gathered before the fire we perceive anew, with joy, one another's faces. And each time faces come to mean more.

Is it not one of the mysteries of life that life should, after all, be so simple? Yes, as simple as Christmas, simple as this. Journeys through the dark to a lighted door, arms open. Laughter-smothered kisses, kiss-smothered laughter. And blessedness in the heart of it all. Here are the verities, all made gay with tinsel! Dear, silly Christmas-card saying and cracker mottoes—let them speak! Or, since still we cannot speak, let us sing! Dearer than memory, brighter than expectation is the ever returning <u>now</u> of Christmas. Why else, each time we greet its return, should happiness ring out in us like a peal of bells?

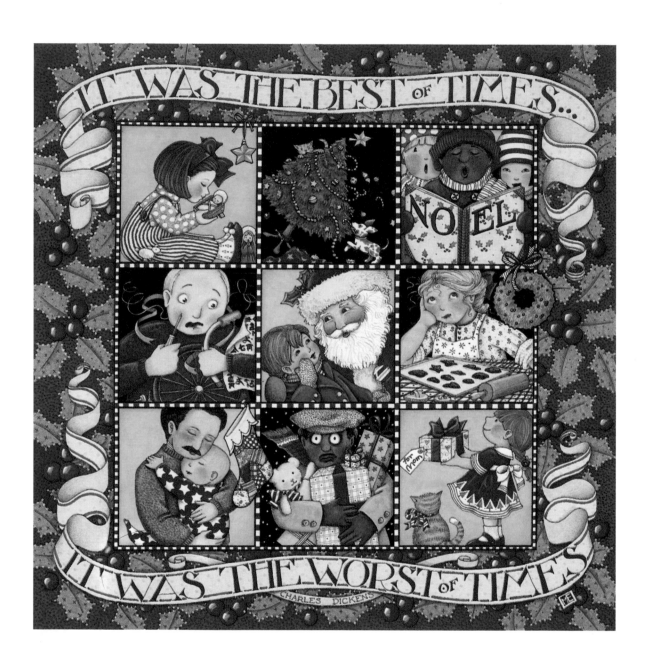

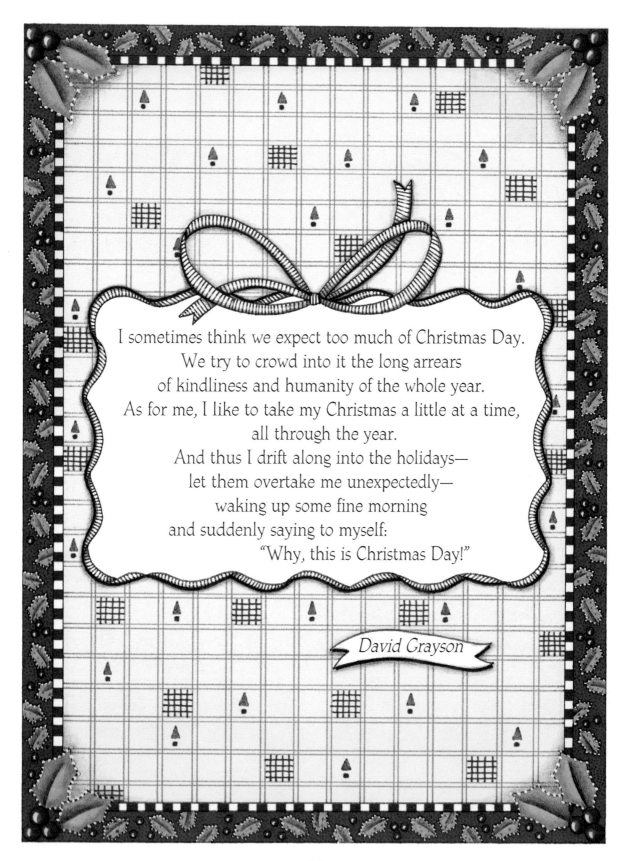

I sometimes think we expect too much of Christmas Day.
We try to crowd into it the long arrears
of kindliness and humanity of the whole year.
As for me, I like to take my Christmas a little at a time,
all through the year.
And thus I drift along into the holidays—
let them overtake me unexpectedly—
waking up some fine morning
and suddenly saying to myself:
"Why, this is Christmas Day!"

David Grayson

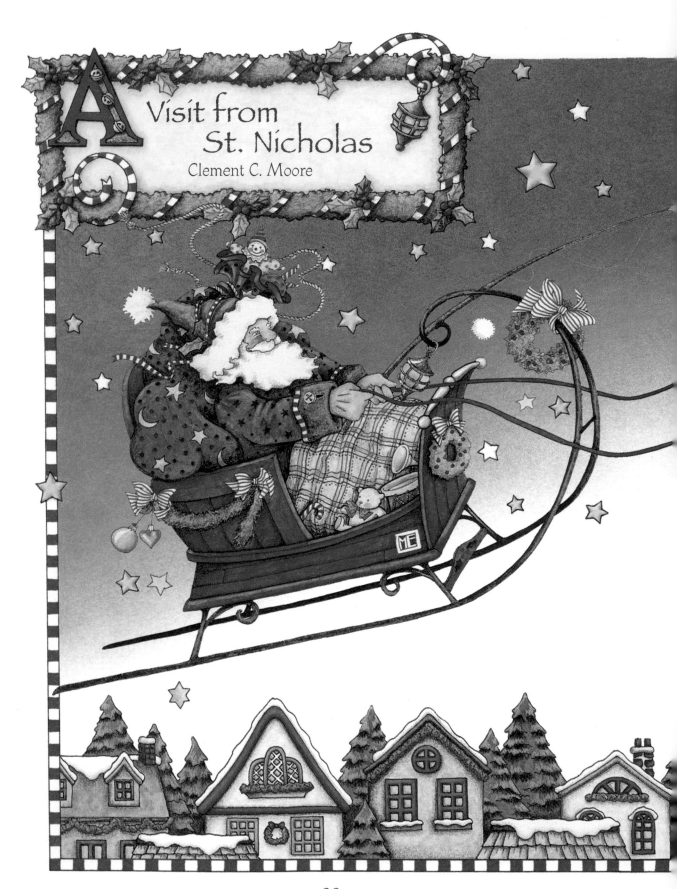

A Visit from St. Nicholas

Clement C. Moore

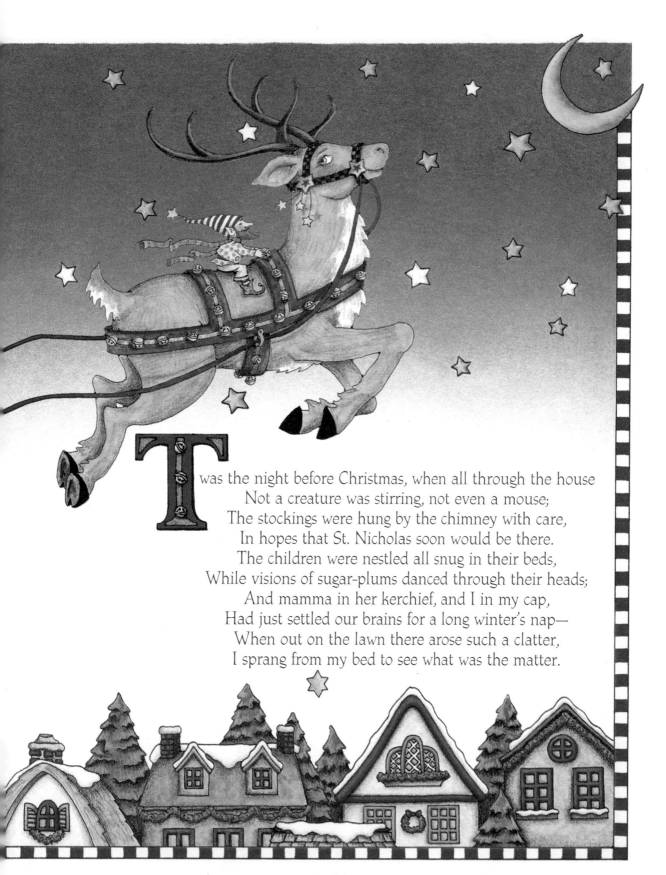

Twas the night before Christmas, when all through the house
Not a creature was stirring, not even a mouse;
The stockings were hung by the chimney with care,
In hopes that St. Nicholas soon would be there.
The children were nestled all snug in their beds,
While visions of sugar-plums danced through their heads;
And mamma in her kerchief, and I in my cap,
Had just settled our brains for a long winter's nap—
When out on the lawn there arose such a clatter,
I sprang from my bed to see what was the matter.

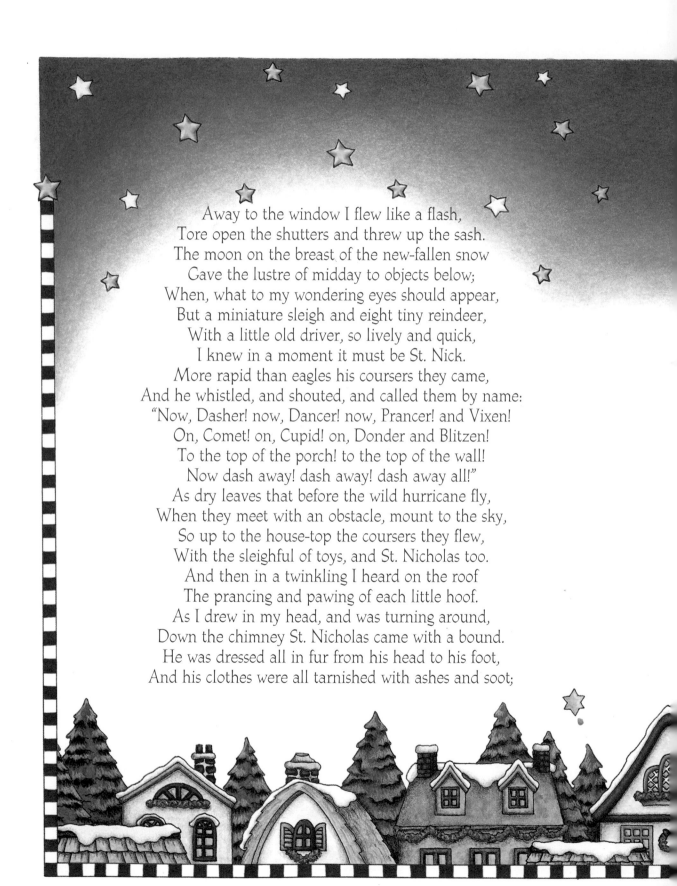

Away to the window I flew like a flash,
Tore open the shutters and threw up the sash.
The moon on the breast of the new-fallen snow
Gave the lustre of midday to objects below;
When, what to my wondering eyes should appear,
But a miniature sleigh and eight tiny reindeer,
With a little old driver, so lively and quick,
I knew in a moment it must be St. Nick.
More rapid than eagles his coursers they came,
And he whistled, and shouted, and called them by name:
"Now, Dasher! now, Dancer! now, Prancer! and Vixen!
On, Comet! on, Cupid! on, Donder and Blitzen!
To the top of the porch! to the top of the wall!
Now dash away! dash away! dash away all!"
As dry leaves that before the wild hurricane fly,
When they meet with an obstacle, mount to the sky,
So up to the house-top the coursers they flew,
With the sleighful of toys, and St. Nicholas too.
And then in a twinkling I heard on the roof
The prancing and pawing of each little hoof.
As I drew in my head, and was turning around,
Down the chimney St. Nicholas came with a bound.
He was dressed all in fur from his head to his foot,
And his clothes were all tarnished with ashes and soot;

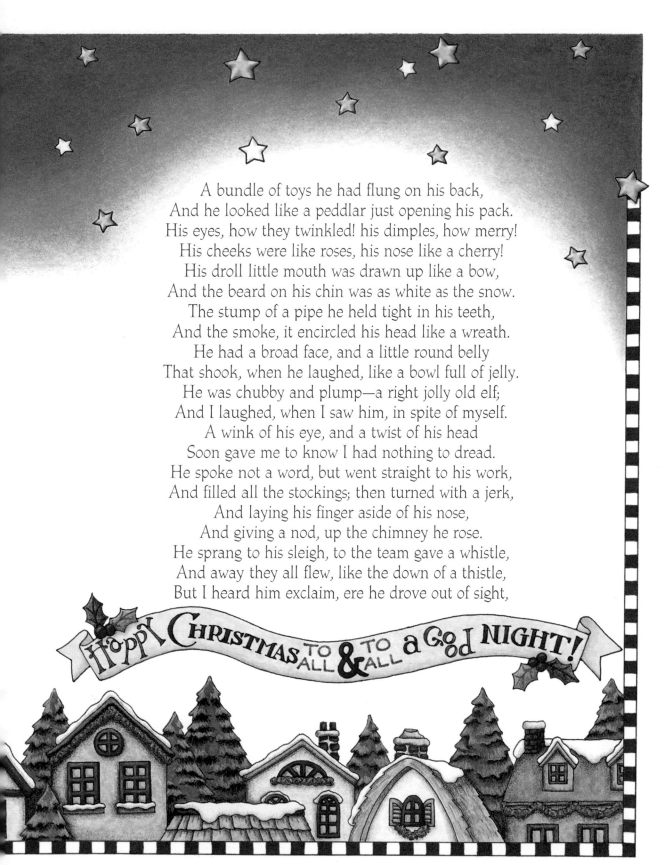

A bundle of toys he had flung on his back,
And he looked like a peddlar just opening his pack.
His eyes, how they twinkled! his dimples, how merry!
His cheeks were like roses, his nose like a cherry!
His droll little mouth was drawn up like a bow,
And the beard on his chin was as white as the snow.
The stump of a pipe he held tight in his teeth,
And the smoke, it encircled his head like a wreath.
He had a broad face, and a little round belly
That shook, when he laughed, like a bowl full of jelly.
He was chubby and plump—a right jolly old elf;
And I laughed, when I saw him, in spite of myself.
A wink of his eye, and a twist of his head
Soon gave me to know I had nothing to dread.
He spoke not a word, but went straight to his work,
And filled all the stockings; then turned with a jerk,
And laying his finger aside of his nose,
And giving a nod, up the chimney he rose.
He sprang to his sleigh, to the team gave a whistle,
And away they all flew, like the down of a thistle,
But I heard him exclaim, ere he drove out of sight,

HAPPY CHRISTMAS TO ALL & TO ALL a GOOD NIGHT!

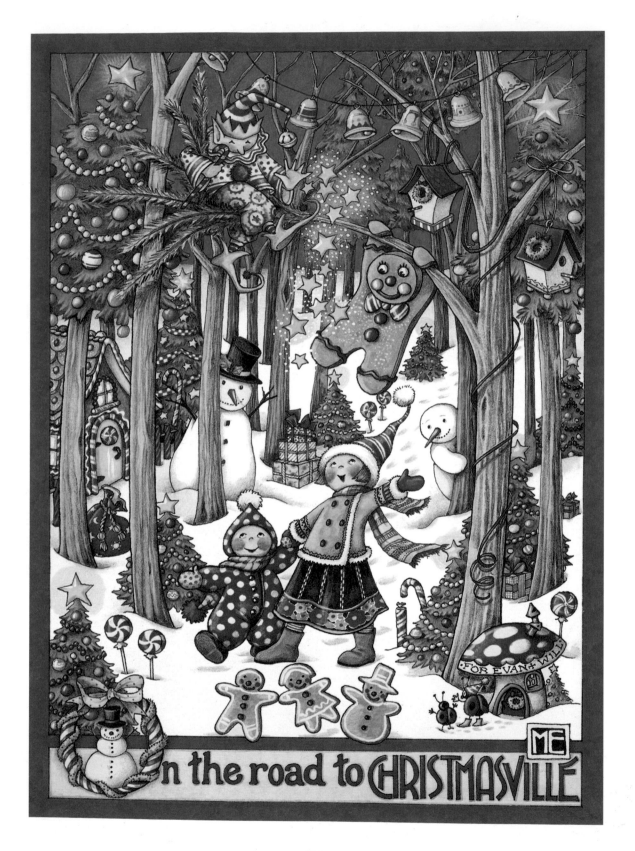

n the road to CHRISTMASVILLE

Toyland

Glen MacDonough and Victor Herbert

Toyland, Toyland,
Little girl and boy land,
While you dwell within it,
You are ever happy then.

Childhood's joyland,
Mystic, merry Toyland!
Once you pass its borders,
You can ne'er return again.

Toyland, Toyland,
Little girl and boy land,
While you dwell within it,
You are ever happy then.

Childhood's joyland,
Mystic, merry Toyland!
Once you pass its borders,
You can ne'er return again.

ifts of the Magi

O. Henry

One dollar and eighty-seven cents. That was all. And 60 cents of it was in pennies. Pennies saved one and two at a time by bulldozing the grocer and the vegetable man and the butcher until one's cheeks burned with the silent imputation of parsimony that such close dealing implied. Three times Della counted it. One dollar and eighty-seven cents. And the next day would be Christmas.

There was clearly nothing to do but flop down on the shabby little couch and howl. So Della did it. Which instigates the moral reflection that life is made up of sobs, sniffles and smiles, with sniffles predominating.

While the mistress of the home is gradually subsiding from the first stage to the second take a look at the home. A furnished flat at $8 per week. It did not exactly beggar description, but it certainly had that word on the lookout for the mendicancy squad.

In the vestibule below belonged to this flat a letter-box into which no letter would go, and an electric button from which no mortal finger could coax a ring. Also appertaining thereunto was a card bearing the name "Mr. James Dillingham Young."

The "Dillingham" had been flung to the breeze during a former period of prosperity when its possessor was being paid $30 per week. Now, when the income was shrunk to $20, the letters of "Dillingham" looked blurred, as though they were thinking seriously of contracting to a modest and

unassuming D. But whenever Mr. James Dillingham Young came home and reached his flat above he was called "Jim" and greatly hugged by Mrs. James Dillingham Young, already introduced to you as Della. Which is all very good.

Della finished her cry and attended to her cheeks with the powder rag. She stood by the window and looked out dully at a gray cat walking a gray fence in a gray backyard. Tomorrow would be Christmas Day, and she had only $1.87 with which to buy Jim a present. She had been saving every penny she could for months, with this result. Twenty dollars a week doesn't go far. Expenses had been greater than she had calculated. They always are. Only $1.87 to buy a present for Jim. Her Jim. Many a happy hour she had spent planning for something nice for him. Something fine and rare and sterling—something just a little bit near to being worthy of the honor of being owned by Jim.

There was a pier-glass between the windows of the room. Perhaps you have seen a pier-glass in an $8 flat. A very thin and very agile person may, by observing his reflection in a rapid sequence of longitudinal strips, obtain a fairly accurate conception of his looks. Della, being slender, had mastered the art.

Suddenly she whirled from the window and stood before the glass. Her eyes were shining brilliantly, but her face had lost its color within twenty seconds. Rapidly she pulled down her hair and let it fall to its full length.

Now, there were two possessions of the James Dillingham Youngs in which they both took a mighty pride. One was Jim's gold watch that had been his father's and his grandfather's. The other was Della's hair.

Had the Queen of Sheba lived in the flat across the airshaft Della would have let her hair hang out the window some day to dry and mocked at Her Majesty's jewels and gifts. Had King Solomon been the janitor, with all his treasures piled up in the basement, Jim would have pulled out his watch every time he passed, just to see him pluck at his beard from envy.

So now Della's beautiful hair fell about her, rippling and shining like a cascade of brown waters. It reached below her knee and made itself almost a garment for her. And then she did it up again nervously and quickly. Once she faltered for a minute and stood still while a tear or two splashed on the worn red carpet.

On went her old brown jacket; on went her old brown hat. With a whirl of skirts and with the brilliant sparkle still in her eyes, she fluttered out the door and down the stairs to the street.

Where she stopped the sign read: "Mme. Sofronie. Hair Goods of All Kinds." One flight up Della ran, and collected herself, panting, before Madame, large, too white, chilly and hardly looking the "Sofronie."

"Will you buy my hair?" asked Della.

"I buy hair," said Madame. "Take yer hat off and let's have a sight at the looks of it."

Down rippled the brown cascade.

"Twenty dollars," said Madame, lifting the mass with a practised hand.

"Give it to me quick," said Della.

Oh, and the next two hours tripped by on rosy wings. Forget the hashed metaphor. She was ransacking the stores for Jim's present.

She found it at last. It surely had been made for Jim and no one else. There was none other like it in any of the stores, and she had turned all of them inside out. It was a platinum fob chain simple and chaste in design, properly proclaiming its value by substance alone and not by meretricious

ornamentation—as all good things should do. It was even worthy of The Watch. As soon as she saw it she knew that it must be Jim's. It was like him. Quietness and value—the description applied to both. Twenty-one dollars they took from her for it, and she hurried home with the 87 cents. With that chain on his watch Jim might be properly anxious about the time in any company. Grand as the watch was, he sometimes looked at it on the sly on account of the old leather strap that he used in place of a chain.

When Della reached home her intoxication gave way a little to prudence and reason. She got out her curling irons and lighted the gas and went to work repairing the ravages made by generosity added to love. Which is always a tremendous task, dear friends—a mammoth task.

Within forty minutes her head was covered with tiny, close-lying curls that made her look wonderfully like a truant schoolboy. She looked at her reflection in the mirror long, carefully, and critically.

"If Jim doesn't kill me," she said to herself, "before he takes a second look at me, he'll say I look like a Coney Island chorus girl. But what could I do—oh, what could I do with a dollar and eighty-seven cents!"

At 7 o'clock the coffee was made and the frying pan was on the back of the stove hot and ready to cook the chops.

Jim was never late. Della doubled the fob chain in her hand and sat on the corner of the table near the door that he always entered. Then she heard his step on the stair away down on the first flight, and she turned white for just a moment. She had a habit of saying little silent prayers about the simplest everyday things, and now she whispered: "Please, God, make him think I am still pretty."

The door opened and Jim stepped in and closed it. He looked thin and very serious. Poor fellow, he was only twenty-two—and to be burdened with a family! He needed a new overcoat and he was without gloves.

Jim stopped inside the door, as immovable as a setter at the scent of quail. His eyes were fixed upon Della, and there was an expression in them that she could not read, and it terrified her. It was not anger, nor surprise, nor disapproval, nor horror, nor any of the sentiments that she had been prepared for. He simply stared at her fixedly with that peculiar expression on his face.

Della wriggled off the table and went for him.

"Jim, darling," she cried, "don't look at me that way. I had my hair cut off and sold it because I couldn't have lived through Christmas without giving you a present. It'll grow again—you won't mind, will you? I just had to do it. My hair grows awfully fast. Say 'Merry Christmas!' Jim, and let's be happy. You don't know what a nice—what a beautiful, nice gift I've got for you."

"You've cut off your hair?" asked Jim, laboriously, as if he had not arrived at that patent fact yet even after the hardest mental labor.

"Cut if off and sold it," said Della. "Don't you like me just as well, any-how? I'm me without my hair, ain't I?"

Jim looked about the room curiously.

"You say your hair is gone?" he said, with an air almost of idiocy.

"You needn't look for it," said Della. "It's sold, I tell you—sold and gone too. It's Christmas Eve, boy. Be good to me, for it went for you. Maybe the hairs of my head were numbered," she went on with a sudden serious sweetness, "but nobody could ever count my love for you. Shall I put the chops on, Jim?"

Out of his trance Jim seemed to quickly wake. He enfolded his Della. For ten seconds let us regard with discreet scrutiny some inconsequential

object in the other direction. Eight dollars a week or a million a year—what is the difference? A mathematician or a wit would give you the wrong answer. The magi brought valuable gifts, but that was not among them. This dark assertion will be illuminated later on.

Jim drew a package from his overcoat pocket and threw it upon the table.

"Don't make any mistake, Dell," he said, "about me. I don't think there's anything in the way of a haircut or a shave or a shampoo that could make me like my girl any less. But if you'll unwrap that package you may see why you had me going awhile at first."

White fingers and nimble tore at the string and paper. And then an ecstatic scream of joy; and then alas! a quick feminine change to hysterical tears and wails, necessitating the immediate employment of all the comforting powers of the lord of the flat.

For there lay The Combs—the set of combs, side and back, that Della had worshipped for long in a Broadway window. Beautiful combs, pure tortoise shell, with jewelled rims—just the shade to wear in the beautiful vanished hair. They were expensive combs, she knew, and her heart had simply craved and yearned over them without the least hope of possession. And now, they were hers, but the tresses that should have adorned the coveted adornments were gone.

But she hugged them to her bosom, and at length she was able to look up with dim eyes and a smile and say: "My hair grows so fast, Jim!"

And then Della leaped up like a little singed cat and cried, "Oh, oh!"

Jim had not yet seen his beautiful present. She held it out to him eagerly upon her open palm. The dull, precious metal seemed to flash with a reflection of her bright and ardent spirit.

"Isn't it a dandy, Jim? I hunted all over town to find it. You'll have to look at the time a hundred times a day now. Give me your watch. I want to see how it looks on it."

Instead of obeying, Jim tumbled down on the couch and put his hands under the back of his head and smiled.

"Dell," said he, "let's put our Christmas presents away and keep 'em a while. They're too nice to use just at present. I sold the watch to get the money to buy your combs. And now suppose you put the chops on."

The magi, as you know, were wise men—wonderfully wise men—who brought gifts to the Babe in the manger. They invented the art of giving Christmas gifts. Being wise, their gifts were no doubt wise ones, possibly bearing the privilege of exchange in case of duplication. And here I have lamely related to you the uneventful chronicle of two foolish children in a flat who most unwisely sacrificed for each other the greatest treasures of their house. But in a last word to the wise of these days let it be said that of all who give gifts these two were of the wisest. Of all who give and receive gifts, such as they are wisest. Everywhere they are wisest. They are the magi.

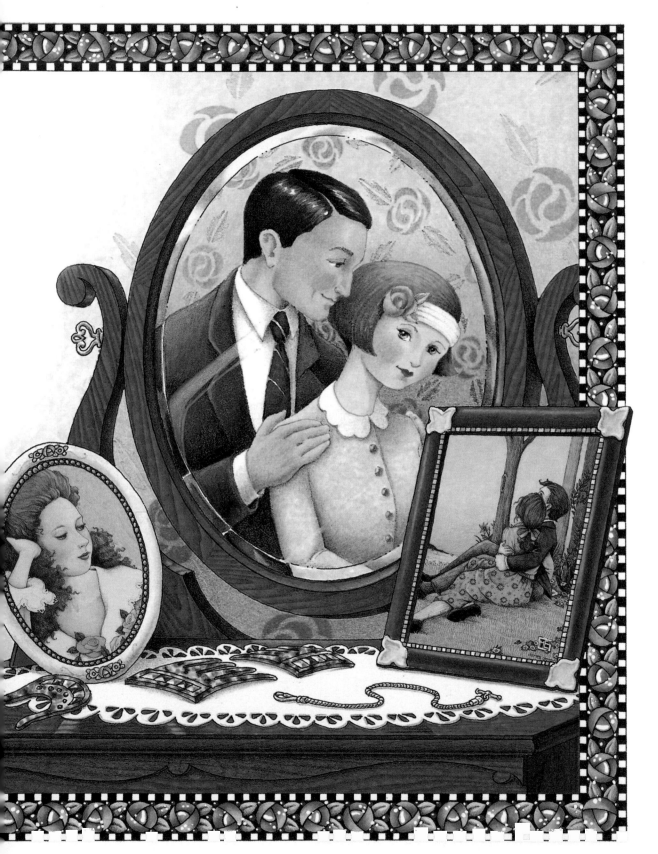

For somehow, not only at Christmas,
 but all the long year through,
The joy that you give to others
 is the joy that comes back to you.

John Greenleaf Whittier

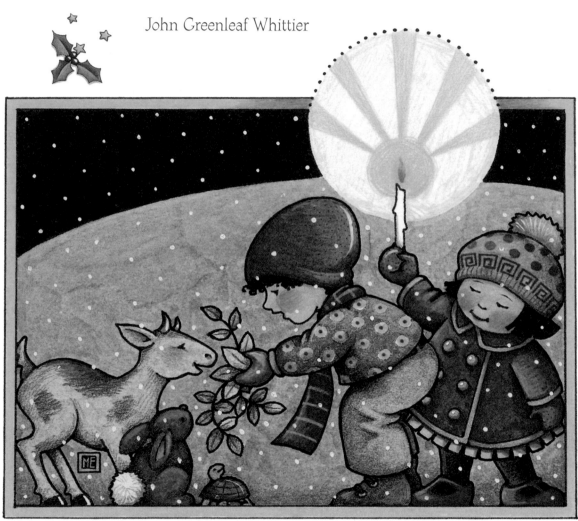

THE FUTURE of MANKIND LIES WAITING for THOSE
WHO WILL COME TO UNDERSTAND THEIR LIVES AND
TAKE UP THEIR RESPONSIBILITIES TO ALL LIVING THINGS.

V. V. DELORIA

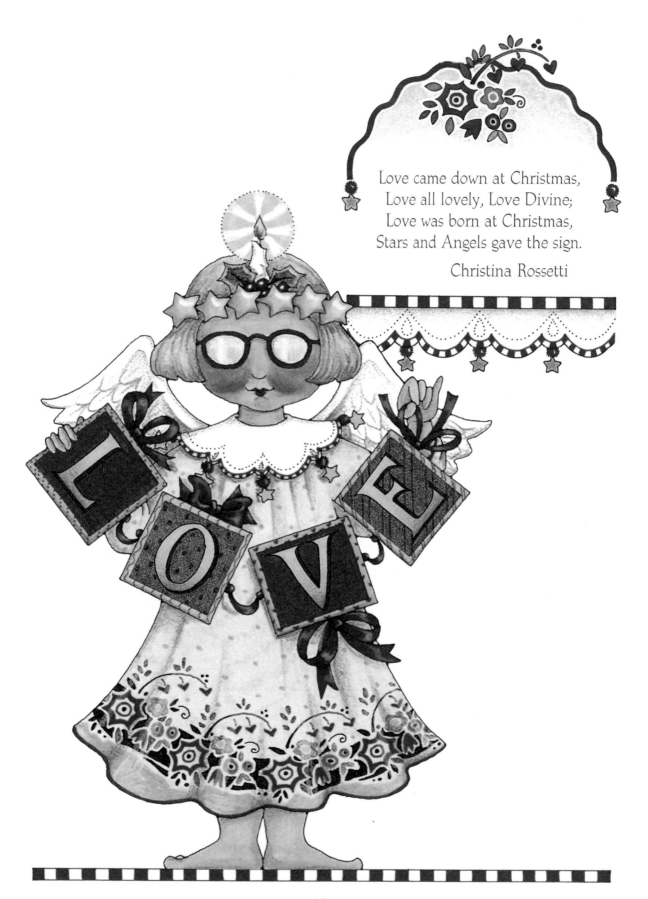

Love came down at Christmas,
Love all lovely, Love Divine;
Love was born at Christmas,
Stars and Angels gave the sign.

Christina Rossetti

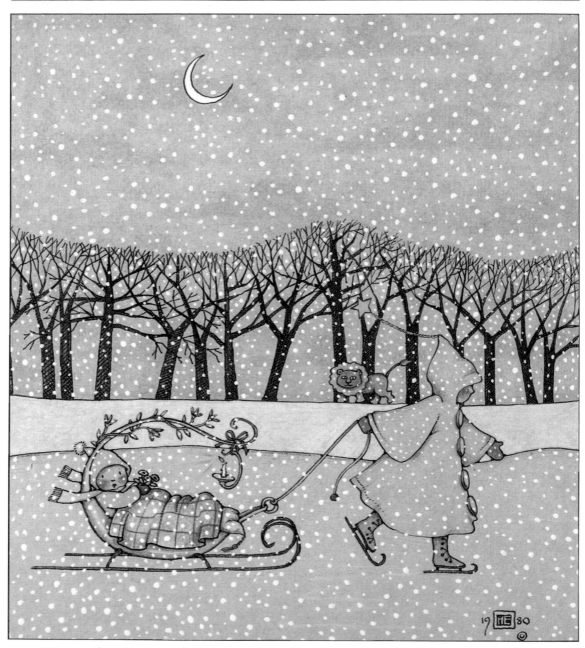

OVER THE RIVER

THROUGH THE WOODS

Over the River
and Through the Woods

Over the river and through the woods
To Grandmother's house we go.
The horse knows the way to carry the sleigh
Through white and drifted snow.
Over the river and through the woods,
Oh, how the wind does blow.
It stings the toes and bites the nose
As over the ground we go.

Over the river and through the woods
To have a full day of play.
Oh, hear the bells ringing ting-a-ling-ling,
For it is Christmas Day.
Over the river and through the woods,
Trot fast my dapple gray;
Spring o'er the ground just like a hound,
For this is Christmas Day.

Over the river and through the woods
And straight through the barnyard gate.
It seems that we go so dreadfully slow;
It is so hard to wait.
Over the river and through the woods,
Now Grandma's cap I spy.
Hurrah for fun; the pudding's done;
Hurrah for the pumpkin pie.

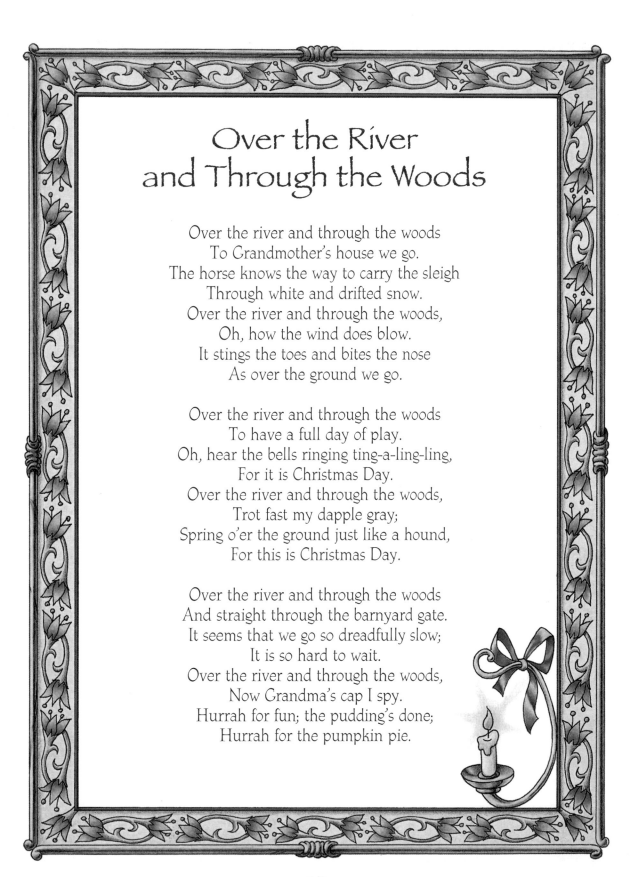

The Substitute Reindeer

Mrs. Roy L. Peifer

Old Rocking-horse stood all alone,
 While the elves packed Santa's sleigh;
His mane was tangled with spider webs
 And his coat all dusty and gray.

All the lovely, new, shining toys
 Were ready and eager to go;
Bells jingled gaily outside the shop
 Where reindeer were pawing the snow.

The Rocking-horse sighed a little sigh,
 "No one wants me any more."
And a great sawdust tear slid from his eye
 And rolled across the floor.

"Nowadays all the children
 Want tractors and trucks and planes,
Mechanical cars to ride in
 And wondrous electric trains.

"I guess I'll just have to be lonely
 Year after empty year,
While all the gleaming, new, modern toys
 Go out to spread Christmas cheer."

But one of the elves came running,
 "Santa, oh Santa, come quick!
Prancer ate too many Christmas greens
 And now he's most dreadfully sick.

"He'll have to be put in the stable
 And stay there all of the night,
With pills and hot-water bottles;
 You cannot use him for your flight.

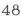

"We've no one to hitch up with Vixen;
 Whatever on earth can we do?"
The Rocking-horse heard and he pleaded,
 "Please, Santa, let me fly with you.

"I'm strong and I'm willing and eager,
 I'll try hard to pull my full share;
For staying behind in the toy shop
 Seems more than I really can bear."

So they brushed Rocking-horse sleek and shiny,
 And the luster came back to his eyes;
The queerest team that you ever did see
 Leaped into the Christmas skies.

How merry the sleigh bells jingled!
 How swift did the runners glide!
Rocking-horse, glad to be useful
 Gave Santa a glorious ride.

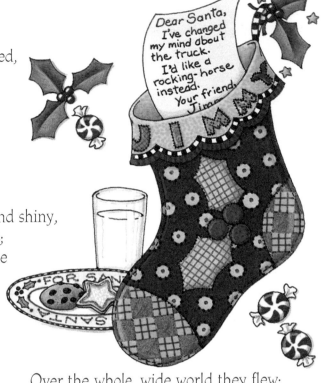

Dear Santa,
I've changed
my mind about
the truck.
I'd like a
rocking-horse
instead.
Your friend,
Jimmy

FOR SANTA

Over the whole, wide world they flew;
 Here, there—and everywhere—
Leaving mountains of lovely toys
 In answer to childish prayer.

They came, at last, to Jimmy's house
 And found a note which read,
"I've changed my mind about the truck;
 I'd like a rocking-horse instead."

Santa whispered to Rocking-horse,
 "The sleigh is empty and light;
If you'd like to make Jimmy happy,
 The reindeer can make it home all right."

Oh what a glorious Christmas!
 Oh what a wonderful joy!
No longer is Rocking-horse lonely—
 He's loved by a little boy!

49

Everywhere, Everywhere Christmas To-night

Phillips Brooks

Christmas in lands of the fir tree and pine,
Christmas in lands of the palm tree and vine;
Christmas where snow peaks stand solemn and white,
Christmas where cornfields lie sunny and bright;
 Everywhere, everywhere Christmas to-night!

Christmas where children are hopeful and gay,
Christmas where old men are patient and gray;
Christmas where peace, like a dove in its flight;
Broods o'er brave men in the thick of the fight;
 Everywhere, everywhere Christmas to-night!

For the Christ child who comes is the Master of all;
No palace too great—no cottage too small.
The angels who welcome Him sing from the height,
"In the city of David, a King in His might."
 Everywhere, everywhere Christmas to-night!

Then let every heart keep its Christmas within,
Christ's pity for sorrow, Christ's hatred of sin,
Christ's care for the weakest, Christ's courage for right,
Christ's dread of the darkness, Christ's love of the light,
 Everywhere, everywhere Christmas to-night!

So the stars of the midnight which compass us round,
Shall see a strange glory and hear a sweet sound,
And cry, "Look! the earth is aflame with delight.
O sons of the morning rejoice at the sight."
 Everywhere, everywhere Christmas to-night!

LOVE IS ALL

50

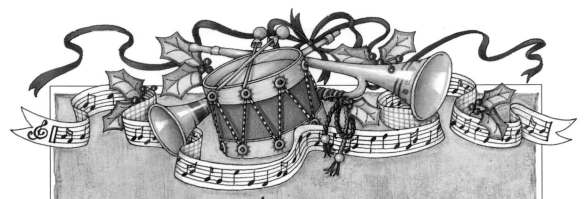

Up on the Housetop

Benjamin Russell Hanby

Up on the housetop reindeer pause;
Out jumps good old Santa Claus,
Down through the chimney with lots of toys,
All for the little ones' Christmas joys.

Ho, ho, ho, who wouldn't go?
Ho, ho, ho, who wouldn't go?
Up on the housetop, click, click, click,
Down through the chimney with good Saint Nick.

First comes the stocking of little Nell;
Oh, dear Santa, fill it well;
Give her a dolly that laughs and cries,
One that can open and shut its eyes.

Ho, ho, ho, who wouldn't go?
Ho, ho, ho, who wouldn't go?
Up on the housetop, click, click, click,
Down through the chimney with good Saint Nick.

Look in the stocking of little Bill;
Oh, just see that glorious fill!
Here is a hammer and lots of tacks,
Whistle and ball and a set of jacks.

Ho, ho, ho, who wouldn't go?
Ho, ho, ho, who wouldn't go?
Up on the housetop, click, click, click,
Down through the chimney with good Saint Nick.

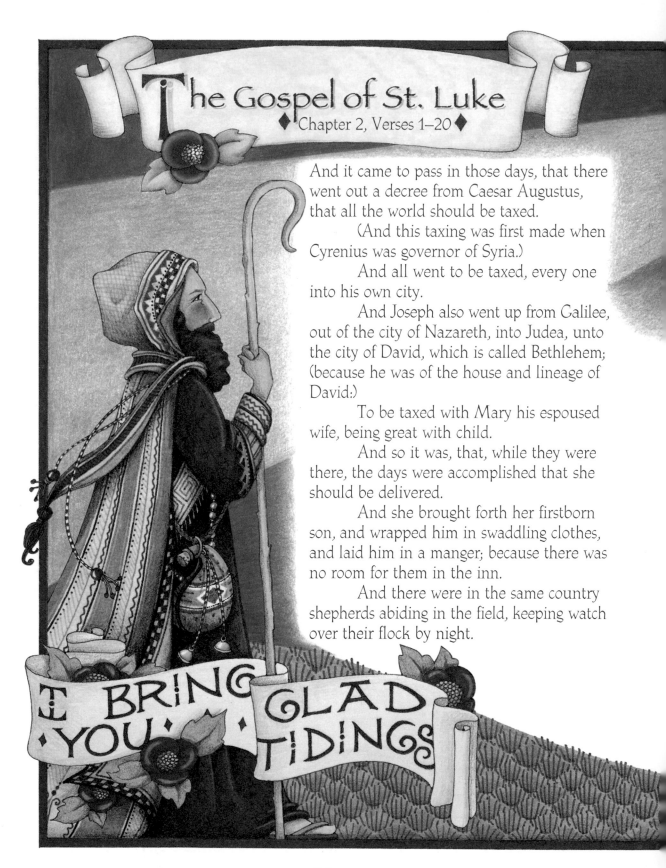

The Gospel of St. Luke
◆ Chapter 2, Verses 1–20 ◆

And it came to pass in those days, that there went out a decree from Caesar Augustus, that all the world should be taxed.

(And this taxing was first made when Cyrenius was governor of Syria.)

And all went to be taxed, every one into his own city.

And Joseph also went up from Galilee, out of the city of Nazareth, into Judea, unto the city of David, which is called Bethlehem; (because he was of the house and lineage of David:)

To be taxed with Mary his espoused wife, being great with child.

And so it was, that, while they were there, the days were accomplished that she should be delivered.

And she brought forth her firstborn son, and wrapped him in swaddling clothes, and laid him in a manger; because there was no room for them in the inn.

And there were in the same country shepherds abiding in the field, keeping watch over their flock by night.

I BRING YOU GLAD TIDINGS

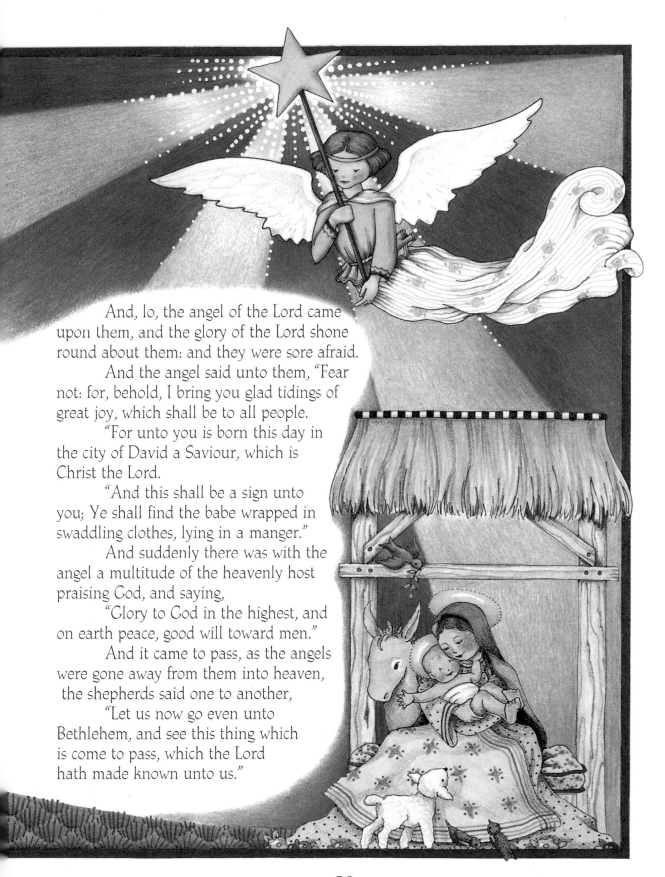

And, lo, the angel of the Lord came upon them, and the glory of the Lord shone round about them: and they were sore afraid.

And the angel said unto them, "Fear not: for, behold, I bring you glad tidings of great joy, which shall be to all people.

"For unto you is born this day in the city of David a Saviour, which is Christ the Lord.

"And this shall be a sign unto you; Ye shall find the babe wrapped in swaddling clothes, lying in a manger."

And suddenly there was with the angel a multitude of the heavenly host praising God, and saying,

"Glory to God in the highest, and on earth peace, good will toward men."

And it came to pass, as the angels were gone away from them into heaven, the shepherds said one to another,

"Let us now go even unto Bethlehem, and see this thing which is come to pass, which the Lord hath made known unto us."

The Friendly Beasts

JESUS OUR BROTHER,
KIND AND GOOD,
WAS HUMBLY BORN
IN A STABLE RUDE,
AND THE FRIENDLY BEASTS
AROUND HIM STOOD,
JESUS OUR BROTHER,
KIND AND GOOD.

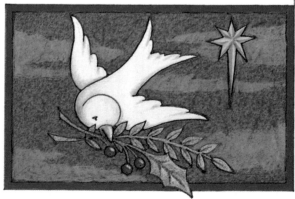

"I," SAID THE DONKEY,
SHAGGY AND BROWN,
"I CARRIED HIS MOTHER
UP HILL AND DOWN;
I CARRIED HER SAFELY
TO BETHLEHEM TOWN."
"I," SAID THE DONKEY,
SHAGGY AND BROWN.

"I," SAID THE COW,
ALL WHITE AND RED,
"I GAVE HIM MY MANGER
FOR HIS BED;
I GAVE HIM MY HAY
TO PILLOW HIS HEAD."
"I," SAID THE COW,
ALL WHITE AND RED.

"I," SAID THE DOVE
FROM THE RAFTERS HIGH,
"COOED HIM TO SLEEP
THAT HE SHOULD NOT CRY;
WE COOED HIM TO SLEEP,
MY MATE AND I."
"I," SAID THE DOVE
FROM THE RAFTERS HIGH.

"I," SAID THE ROOSTER,
WITH THE SHINING EYE,
"I CROWED THE NEWS
UP TO THE SKY.
WHEN THE SUN AROSE,
I CROWED TO THE SKY."
"I," SAID THE ROOSTER,
WITH THE SHINING EYE.

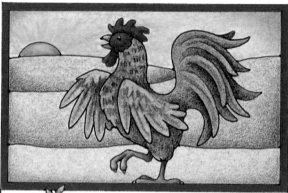

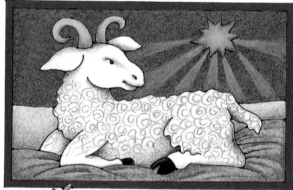

"I," SAID THE SHEEP
WITH CURLY HORN,
"I GAVE HIM MY WOOL
FOR HIS BLANKET WARM;
HE WORE MY COAT
ON CHRISTMAS MORN."
"I," SAID THE SHEEP
WITH CURLY HORN.

"I," SAID THE CAMEL,
YELLOW AND BLACK,
"OVER THE DESERT,
UPON MY BACK,
I BROUGHT HIM A GIFT
IN THE WISE MEN'S PACK."
"I," SAID THE CAMEL,
YELLOW AND BLACK.

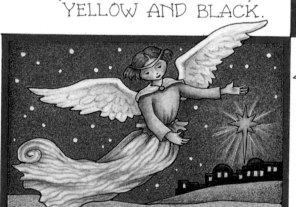

THUS EVERY BEAST
BY SOME GOOD SPELL,
IN THE STABLE DARK
WAS GLAD TO TELL
OF THE GIFT HE GAVE
EMMANUEL,
THE GIFT HE GAVE
EMMANUEL.

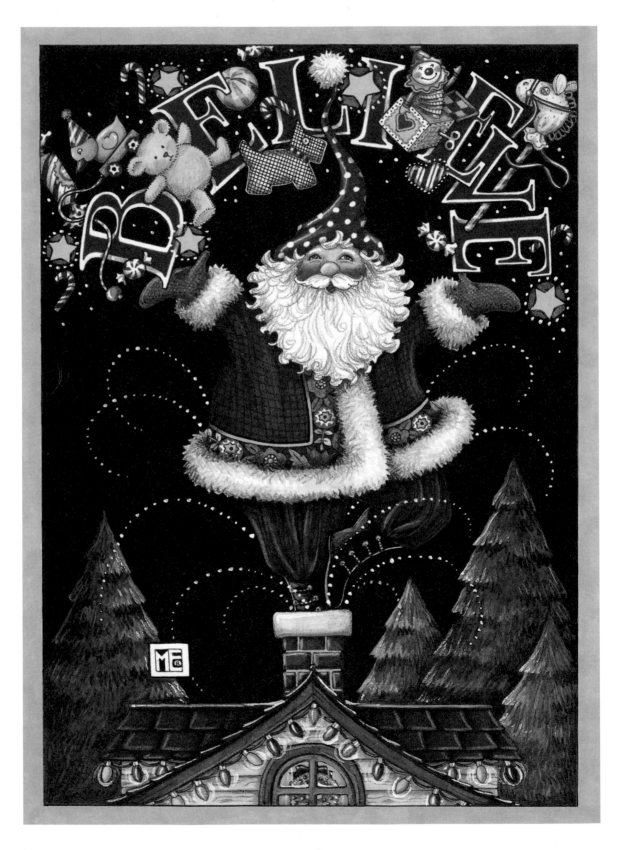

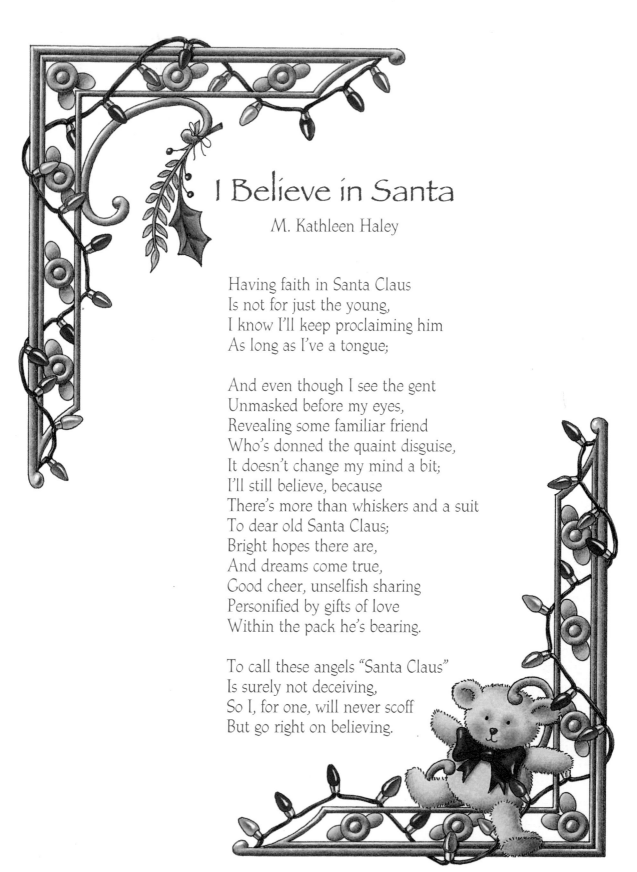

I Believe in Santa

M. Kathleen Haley

Having faith in Santa Claus
Is not for just the young,
I know I'll keep proclaiming him
As long as I've a tongue;

And even though I see the gent
Unmasked before my eyes,
Revealing some familiar friend
Who's donned the quaint disguise,
It doesn't change my mind a bit;
I'll still believe, because
There's more than whiskers and a suit
To dear old Santa Claus;
Bright hopes there are,
And dreams come true,
Good cheer, unselfish sharing
Personified by gifts of love
Within the pack he's bearing.

To call these angels "Santa Claus"
Is surely not deceiving,
So I, for one, will never scoff
But go right on believing.

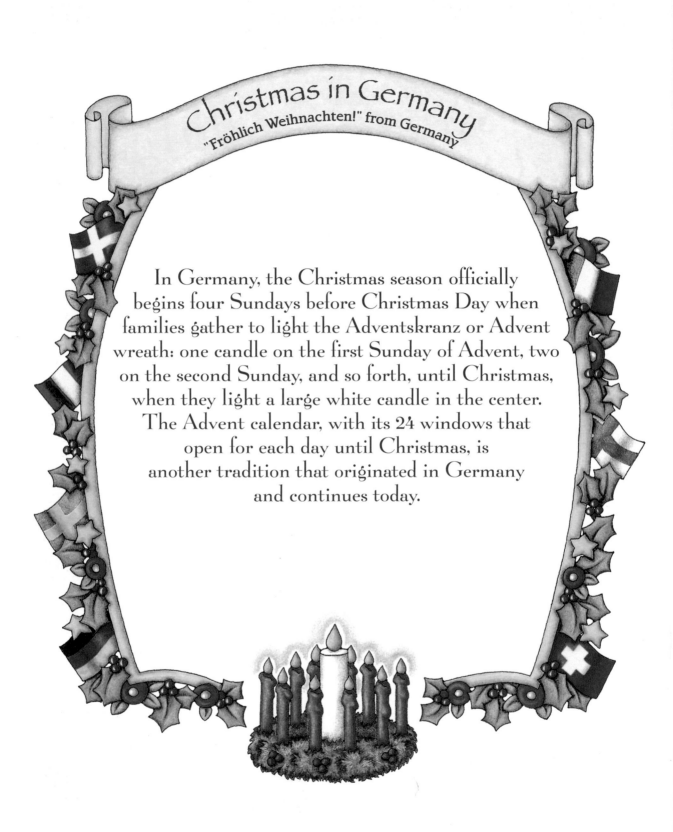

Christmas in Germany

"Fröhlich Weihnachten!" from Germany

In Germany, the Christmas season officially begins four Sundays before Christmas Day when families gather to light the Adventskranz or Advent wreath: one candle on the first Sunday of Advent, two on the second Sunday, and so forth, until Christmas, when they light a large white candle in the center. The Advent calendar, with its 24 windows that open for each day until Christmas, is another tradition that originated in Germany and continues today.

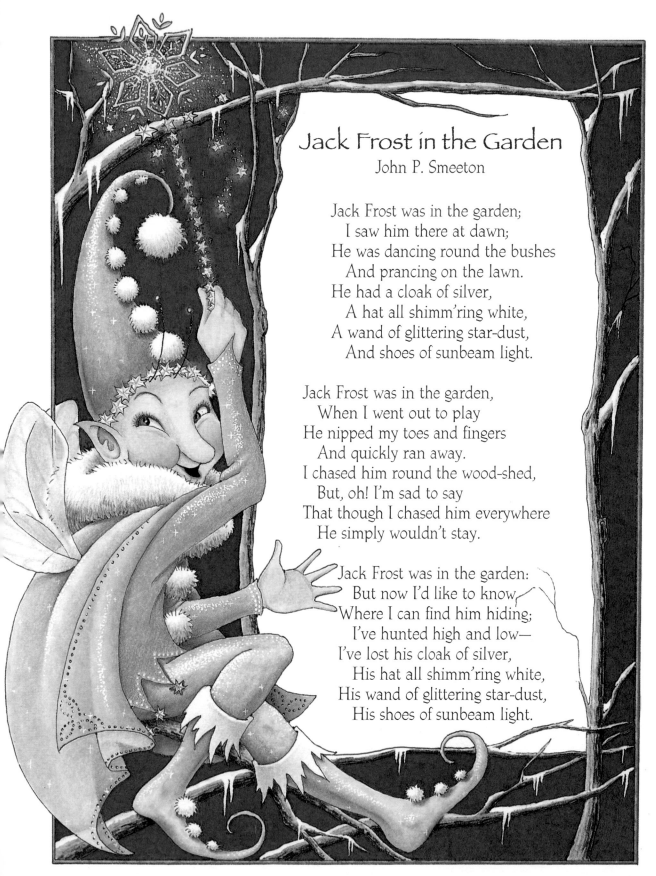

Jack Frost in the Garden
John P. Smeeton

Jack Frost was in the garden;
 I saw him there at dawn;
He was dancing round the bushes
 And prancing on the lawn.
He had a cloak of silver,
 A hat all shimm'ring white,
A wand of glittering star-dust,
 And shoes of sunbeam light.

Jack Frost was in the garden,
 When I went out to play
He nipped my toes and fingers
 And quickly ran away.
I chased him round the wood-shed,
 But, oh! I'm sad to say
That though I chased him everywhere
 He simply wouldn't stay.

Jack Frost was in the garden:
 But now I'd like to know
Where I can find him hiding;
 I've hunted high and low—
I've lost his cloak of silver,
 His hat all shimm'ring white,
His wand of glittering star-dust,
 His shoes of sunbeam light.

from A Christmas Carol
Charles Dickens

nce upon a time—of all the good days in the year, on Christmas Eve—old Scrooge sat busy in his counting-house. It was cold, bleak, biting weather: foggy withal: and he could hear the people in the court outside, go wheezing up and down, beating their hands upon their breasts, and stamping their feet upon the pavement stones to warm them. The city clocks had only just gone three, but it was quite dark already—it had not been light all day—and candles were flaring in the windows of the neighbouring offices, like ruddy smears upon the palpable brown air. The fog came pouring in at every chink and keyhole, and was so dense without, that although the court was of the narrowest, the houses opposite were mere phantoms. To see the dingy cloud come drooping down, obscuring everything, one might have thought that Nature lived hard by, and was brewing on a large scale.

The door of Scrooge's counting-house was open that he might keep his eye upon his clerk, who in a dismal little cell beyond, a sort of tank, was copying letters. Scrooge had a very small fire, but the clerk's fire was so very much smaller that it looked like one coal. But he couldn't replenish it, for Scrooge kept the coal-box in his own room; and so surely as the clerk came in with the shovel, the master predicted that it would be necessary for them to part. Wherefore the clerk put on his white comforter, and tried to warm himself at the candle; in which effort, not being a man of a strong imagination, he failed.

"A merry Christmas, uncle! God save you!" cried a cheerful voice. It was the voice of Scrooge's nephew, who came upon him so quickly that this was the first intimation he had of his approach.

"Bah!" said Scrooge, "Humbug!"

He had so heated himself with rapid walking in the fog and frost, this nephew of Scrooge's, that he was all in a glow; his face was ruddy and handsome; his eyes sparkled, and his breath smoked again.

"Christmas a humbug, uncle!" said Scrooge's nephew. "You don't mean that, I am sure?"

"I do," said Scrooge. "Merry Christmas! What right have you to be merry? What reason have you to be merry? You're poor enough."

"Come then," returned the nephew gaily. "What right have you to be dismal? What reason have you to be morose? You're rich enough."

Scrooge having no better answer ready on the spur of the moment, said, "Bah!" again; and followed it up with "Humbug."

"Don't be cross, uncle!" said the nephew.

"What else can I be," returned the uncle, "when I live in such a world of fools as this? Merry Christmas! Out upon Merry Christmas! What's Christmas time to you but a time for paying bills without money; a time for finding yourself a year older, but not an hour richer; a time for balancing your books and having every item in 'em through a round dozen of months presented dead against you? If I could work my will," said Scrooge indignantly, "every idiot who goes about with 'Merry Christmas' on his lips, should be boiled with his own pudding, and buried with a stake of holly through his heart. He should!"

"Uncle!" pleaded the nephew.

"Nephew!" returned the uncle, sternly, "keep Christmas in your own way, and let me keep it in mine."

"Keep it!" repeated Scrooge's nephew. "But you don't keep it."

"Let me leave it alone, then," said Scrooge. "Much good may it do you! Much good it has ever done you!"

"There are many things from which I might have derived good, by which I have not profited, I dare say," returned the nephew. "Christmas among the rest. But I am sure I have always thought of Christmas time, when it has come round —apart from the veneration due to its sacred name and origin, if anything belonging to it can be apart from that—as a good time; a kind, forgiving, charitable, pleasant time; the only time I know of, in the long calendar of the year, when men and women seem by one consent to open their shut-up hearts freely, and to think of people below them as if they really were fellow-passengers to the grave, and not another race of creatures bound on other journeys. And therefore, uncle, though it has never put a scrap of gold or silver in my pocket, I believe that it <u>has</u> done me good, and <u>will</u> do me good; and I say, God bless it!"

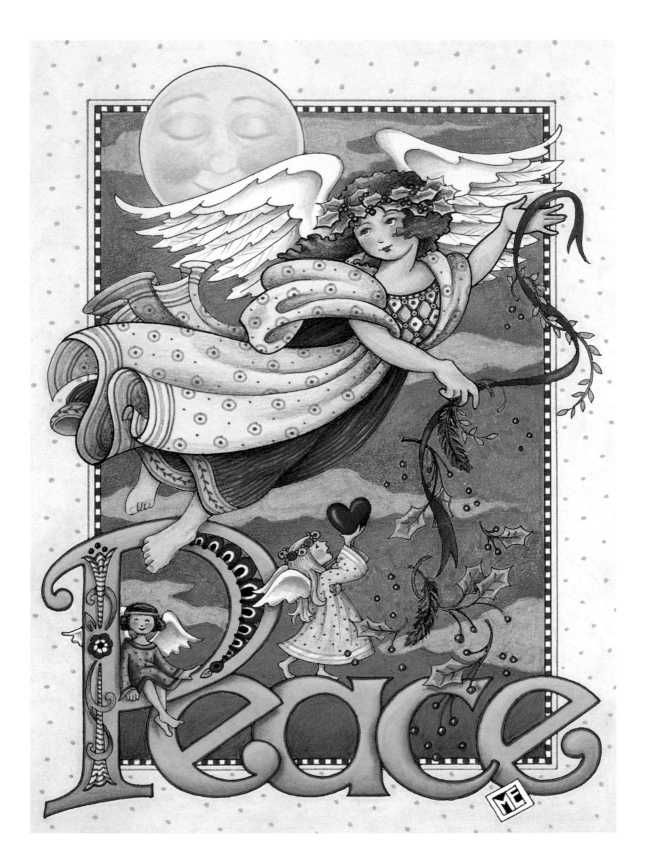

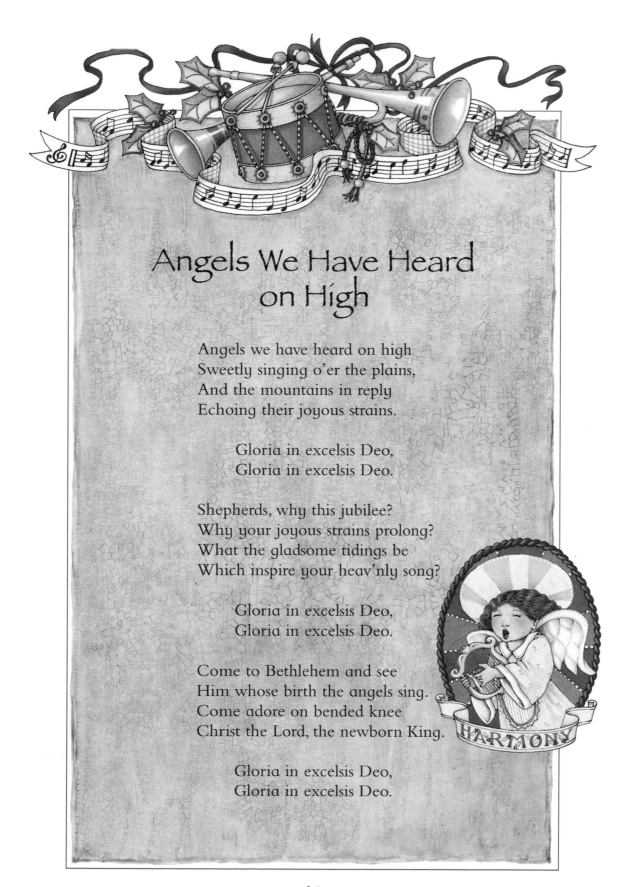

Angels We Have Heard on High

Angels we have heard on high
Sweetly singing o'er the plains,
And the mountains in reply
Echoing their joyous strains.

Gloria in excelsis Deo,
Gloria in excelsis Deo.

Shepherds, why this jubilee?
Why your joyous strains prolong?
What the gladsome tidings be
Which inspire your heav'nly song?

Gloria in excelsis Deo,
Gloria in excelsis Deo.

Come to Bethlehem and see
Him whose birth the angels sing.
Come adore on bended knee
Christ the Lord, the newborn King.

Gloria in excelsis Deo,
Gloria in excelsis Deo.

HARMONY

Little Tree

E. E. Cummings

little tree
little silent Christmas tree
you are so little
you are more like a flower

who found you in the green forest
and were you very sorry to come away?
see i will comfort you
because you smell so sweetly

i will kiss your cool bark
and hug you safe and tight
just as your mother would,
only don't be afraid

look the spangles
that sleep all the year in a dark box
dreaming of being taken out and allowed to shine,
the balls the chains red and gold the fluffy threads,

put up your little arms
and i'll give them all to you to hold
every finger shall have its ring
and there won't be a single place dark or unhappy

then when you're quite dressed
you'll stand in the window for everyone to see
and how they'll stare!
oh but you'll be very proud

and my little sister and i will take hands
and looking up at our beautiful tree
we'll dance and sing
"Noel Noel"

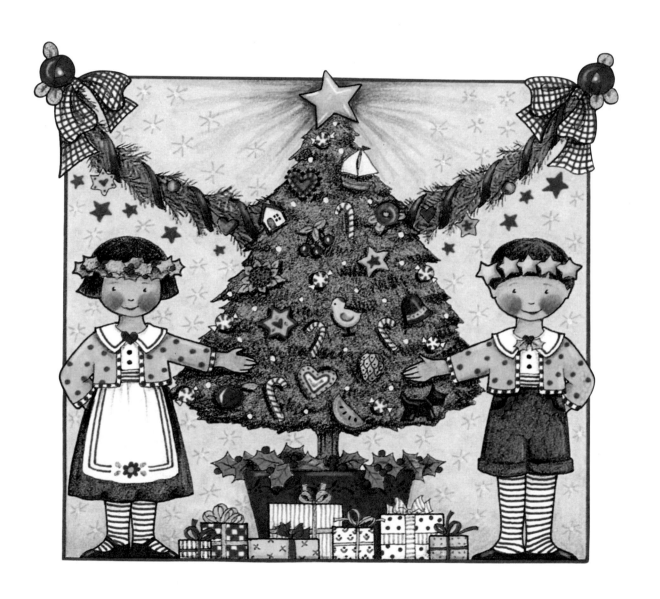

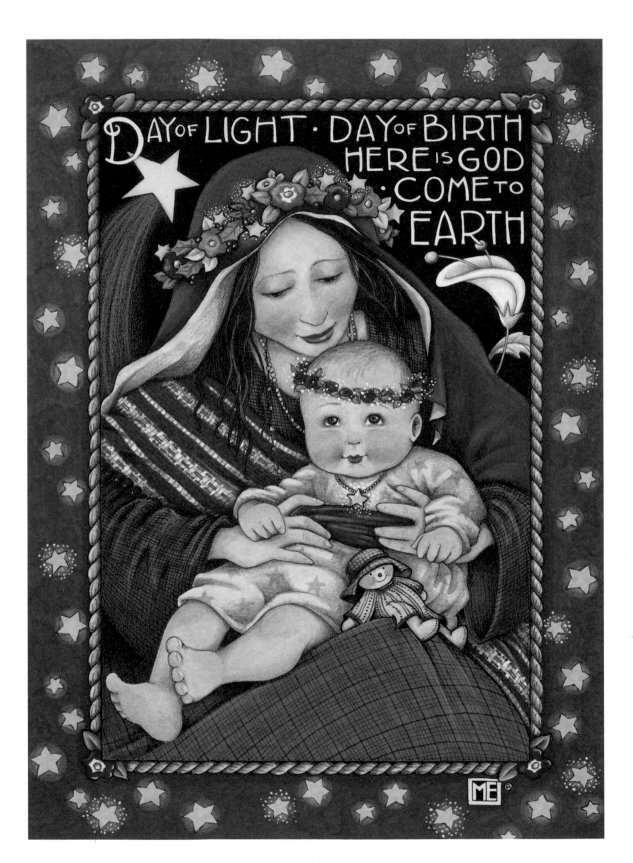

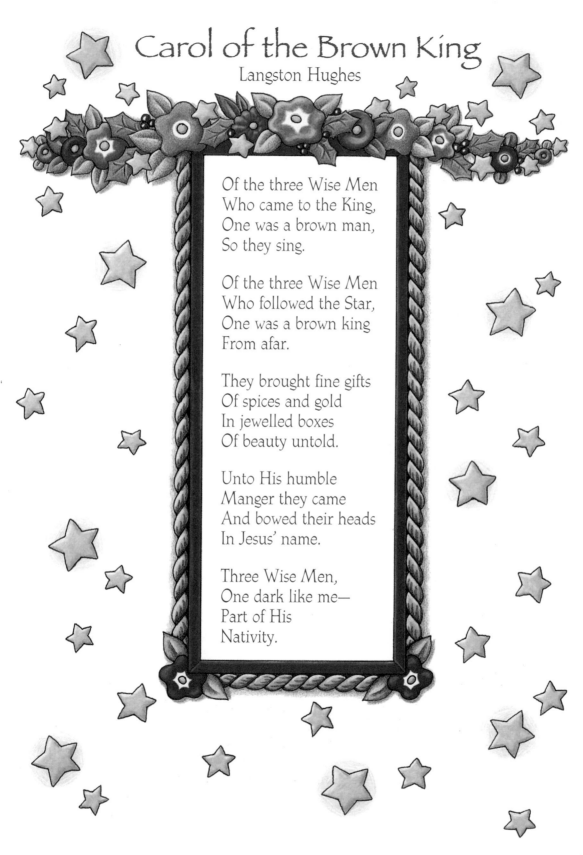

Carol of the Brown King

Langston Hughes

Of the three Wise Men
Who came to the King,
One was a brown man,
So they sing.

Of the three Wise Men
Who followed the Star,
One was a brown king
From afar.

They brought fine gifts
Of spices and gold
In jewelled boxes
Of beauty untold.

Unto His humble
Manger they came
And bowed their heads
In Jesus' name.

Three Wise Men,
One dark like me—
Part of His
Nativity.

Another Boy

The Story of the Birth at Bethlehem
Bruce Barton

Sleepless and bewildered but gloriously proud, the husband of Mary emerged from the stable and made his way to the census taker's booth. For it was the decree of Imperial Rome, ordering a general census, that had brought them to Bethlehem.

The angels' song hummed through his heart and timed his steps with its rhythm; his fine, bronzed face was radiant with the wonder of

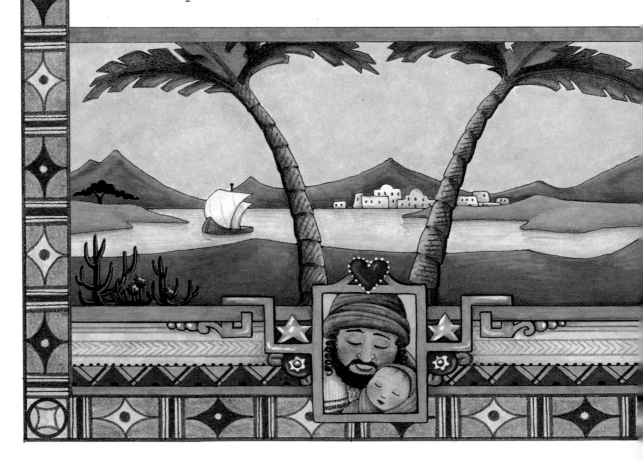

the night. But enrollment blanks and reckonings kept the census taker busy, and all he saw was another peasant standing in the line.

"Name?" he demanded in a routine tone.

"Joseph, carpenter, of Nazareth, of the house of David."

"Married?"

"Yes."

"Wife's name?"

"Mary."

"Children?"

The sturdy young carpenter drew himself up. "One child," he answered proudly. "A son, Jesus, born last night."

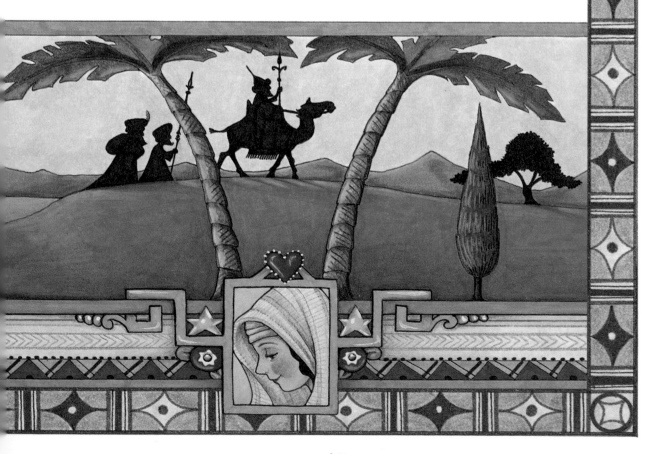

Was there any comment? Did the petty government official who wrote for the first time the name that was to be "above every name"— did he wonder as he wrote? Probably not. It was just one more name on the census roll. Just another boy.

What laughter would have rung through Rome if someone had pointed to that name and said, "There is the beginning of the end of your empire and of all empires everywhere." Yet it would have been true. Democracy began, and thrones began to totter when He said: "You are sons of God." For if all men are sons of God, then all are brothers, and the poorest are entitled to equal rights and privileges with the King. Rome would have laughed, and Rome is dead. The

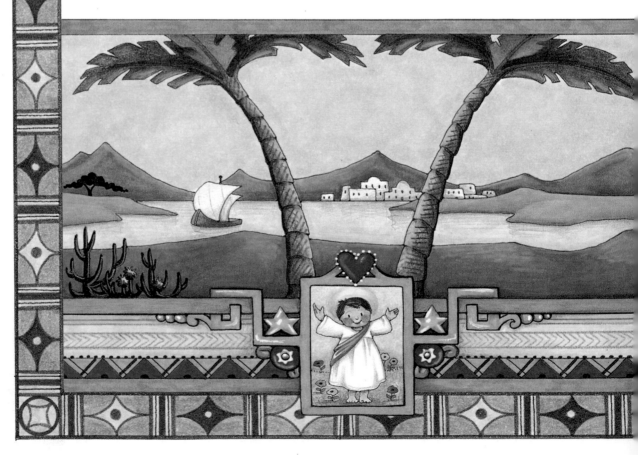

influence of the Child lives on, uplifting the standards of action and thought, inspiring laws, enlisting the strong in service to the needy and the weak.

We celebrate His birthday, and the festival of all children everywhere. They, not we, are the really important people of the earth. In cradles, and at the foot of Christmas trees, are the lives that are to overthrow and rebuild all that we have built. Nothing is so powerful or so perfect that it cannot be transformed utterly by the miracle of another girl. Or another boy.

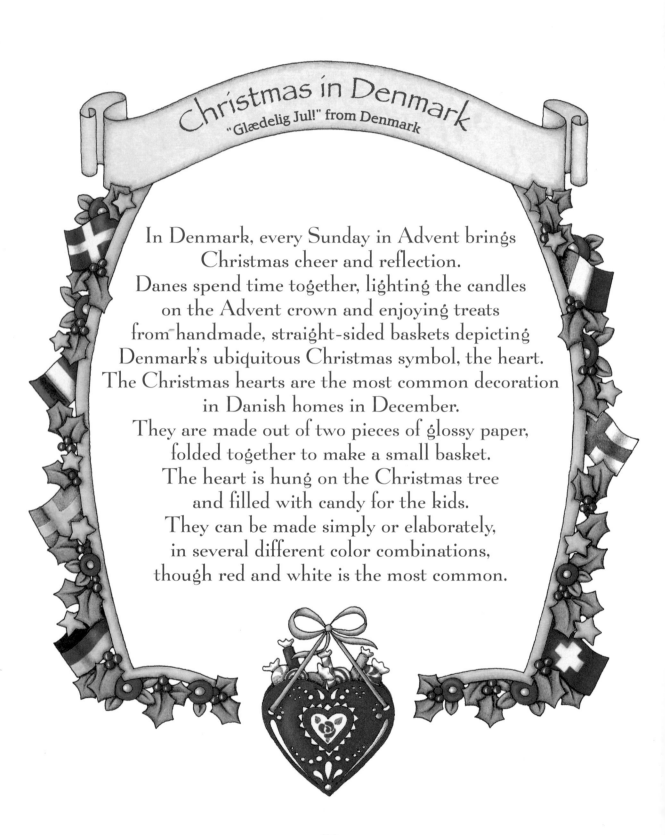

Christmas in Denmark

"Glædelig Jul!" from Denmark

In Denmark, every Sunday in Advent brings
Christmas cheer and reflection.
Danes spend time together, lighting the candles
on the Advent crown and enjoying treats
from handmade, straight-sided baskets depicting
Denmark's ubiquitous Christmas symbol, the heart.
The Christmas hearts are the most common decoration
in Danish homes in December.
They are made out of two pieces of glossy paper,
folded together to make a small basket.
The heart is hung on the Christmas tree
and filled with candy for the kids.
They can be made simply or elaborately,
in several different color combinations,
though red and white is the most common.

Have Yourself a Merry Little Christmas

Hugh Martin and Ralph Blane

Have yourself a merry little Christmas;
Let your heart be light.
From now on, our troubles will be out of sight.

Have yourself a merry little Christmas;
Make the Yuletide gay.
From now on, our troubles will be miles away.

Here we are as in olden days,
 happy golden days of yore
Faithful friends who are dear to us
 gather near to us once more.

Through the years we all will
 be together
 If the Fates allow.
Hang a shining star
 upon the highest bough,
 And have yourself
 a merry little Christmas now.

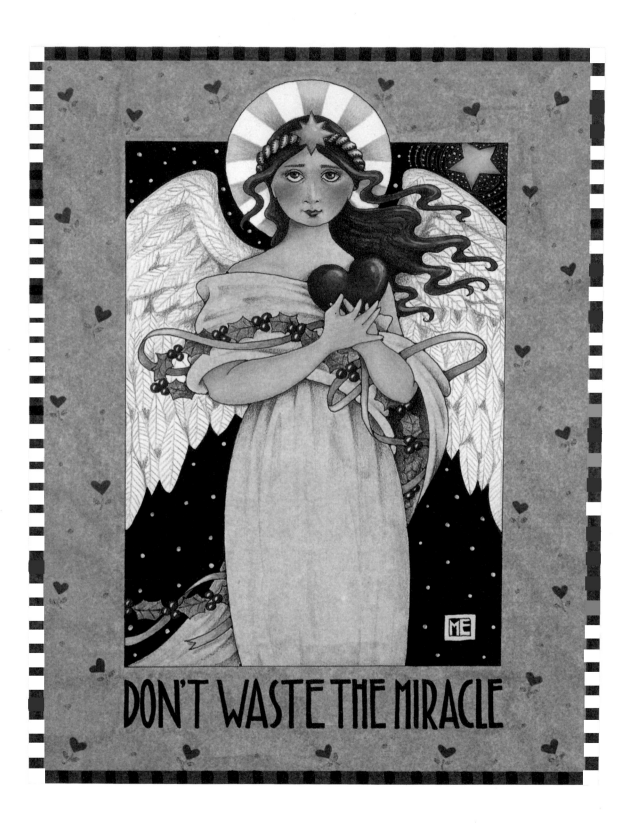

DON'T WASTE THE MIRACLE

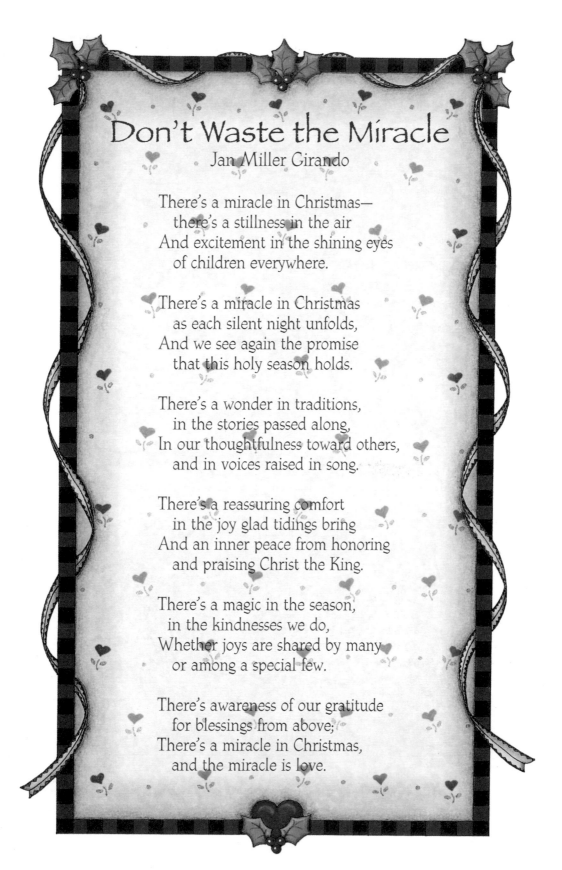

Don't Waste the Miracle

Jan Miller Girando

There's a miracle in Christmas—
 there's a stillness in the air
And excitement in the shining eyes
 of children everywhere.

There's a miracle in Christmas
 as each silent night unfolds,
And we see again the promise
 that this holy season holds.

There's a wonder in traditions,
 in the stories passed along,
In our thoughtfulness toward others,
 and in voices raised in song.

There's a reassuring comfort
 in the joy glad tidings bring
And an inner peace from honoring
 and praising Christ the King.

There's a magic in the season,
 in the kindnesses we do,
Whether joys are shared by many
 or among a special few.

There's awareness of our gratitude
 for blessings from above;
There's a miracle in Christmas,
 and the miracle is love.

May Your Christmas be a Happy One And may the New Year bring you Contentment and Prosperity in overflowing measure.

When there is room in the heart,
there is room in the house.

Danish proverb

We shall light a
candle of understanding
in our hearts
which shall not
be put out.

Sweet is the smile of home;
the mutual look,
When hearts are of each other sure.

John Keble

Deep in the winter night, the family will come one by one, carrying great and small boxes, brilliant in all colors, ribboned in red and green, silver and gold, bright blue, placing them under me with the hands of their hearts, until all around me they are piled high, climbing up into my branches, spilling over onto the floor about me. In the early morning, with all my candles burning and all my brilliant colors standing out and twinkling in their light, the children in their pajamas and woolen slippers rub their sleeping eyes and stare at me in amazement. The mother with her hair hanging down her back smiles and glances here and there, and the father looks up and down at me, quiet and pleased . . . for I am the Christmas tree.

Fritz Peters

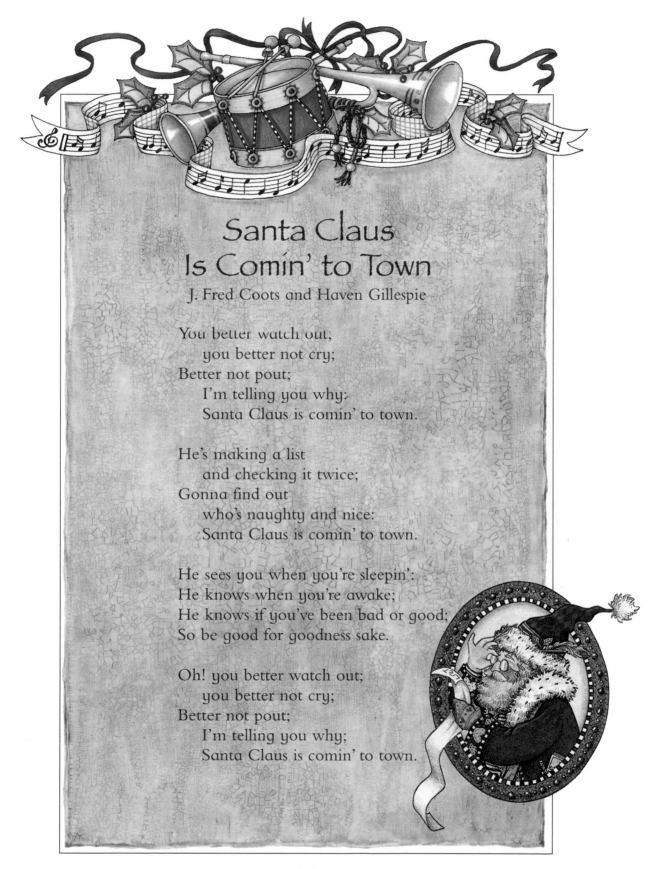

Santa Claus Is Comin' to Town

J. Fred Coots and Haven Gillespie

You better watch out;
 you better not cry;
Better not pout;
 I'm telling you why:
 Santa Claus is comin' to town.

He's making a list
 and checking it twice;
Gonna find out
 who's naughty and nice:
 Santa Claus is comin' to town.

He sees you when you're sleepin':
He knows when you're awake;
He knows if you've been bad or good;
So be good for goodness sake.

Oh! you better watch out;
 you better not cry;
Better not pout;
 I'm telling you why;
 Santa Claus is comin' to town.

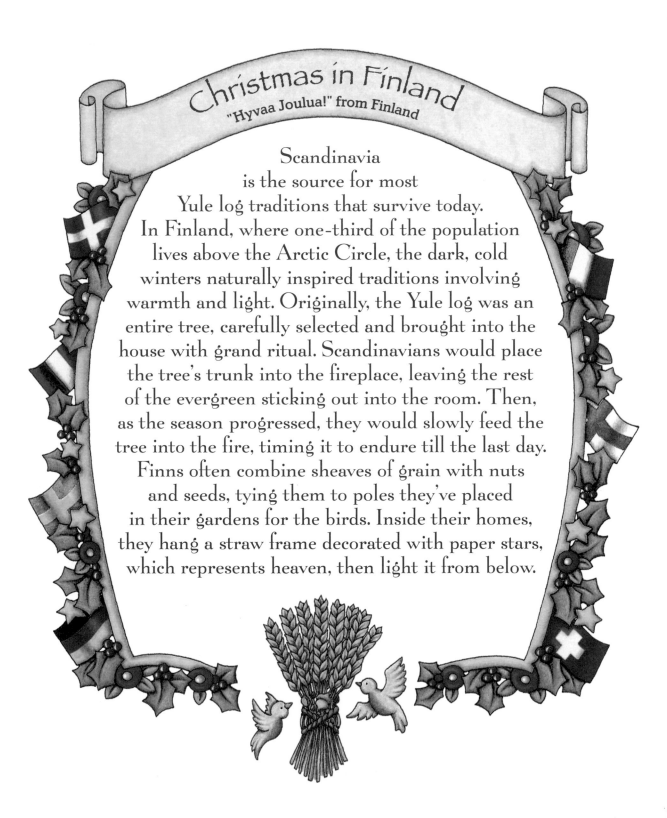

Christmas in Finland

"Hyvaa Joulua!" from Finland

Scandinavia
is the source for most
Yule log traditions that survive today.
In Finland, where one-third of the population
lives above the Arctic Circle, the dark, cold
winters naturally inspired traditions involving
warmth and light. Originally, the Yule log was an
entire tree, carefully selected and brought into the
house with grand ritual. Scandinavians would place
the tree's trunk into the fireplace, leaving the rest
of the evergreen sticking out into the room. Then,
as the season progressed, they would slowly feed the
tree into the fire, timing it to endure till the last day.
Finns often combine sheaves of grain with nuts
and seeds, tying them to poles they've placed
in their gardens for the birds. Inside their homes,
they hang a straw frame decorated with paper stars,
which represents heaven, then light it from below.

Little Jesus

Francis Thompson

Ex ore infantium, Deus, et lactentium
perfecisti laudem
Little Jesus, wast Thou shy
 Once, and just so small as I?
And what did it feel like to be
Out of Heaven, and just like me?
Didst thou sometimes think of there,
And ask where all the angels were?
I should think that I would cry
For my house all made of sky;
I would look about the air,
And wonder where my angels were;
And at waking 'twould distress me—
Not an angel there to dress me!
Hadst Thou ever any toys,
Like us little girls and boys?
And didst Thou play in Heaven with all
The angels that were not too tall,
With stars for marbles? Did the things
Play *Can you see me?* through their wings?
And did Thy Mother let Thee spoil
Thy robes, with playing on *our* soil?
How nice to have them always new
In Heaven, because 'twas quite clean blue! . . .
Thou canst not have forgotten all
That it feels like to be small:
And Thou know'st I cannot pray
To Thee in my father's way—
When Thou wast so little, say,
Couldst Thou talk Thy Father's way?—
 So, a little Child, come down
 And hear a child's tongue like Thy own;

Take me by the hand and walk,
And listen to my baby-talk.
To Thy Father show my prayer
(He will look, Thou art so fair),
And say: "O Father, I, Thy Son,
Bring the prayer of a little one."
And He will smile, that children's tongue
Has not changed since Thou wast young!

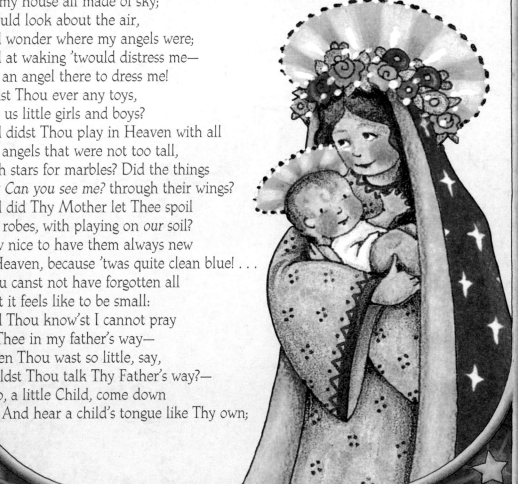

81

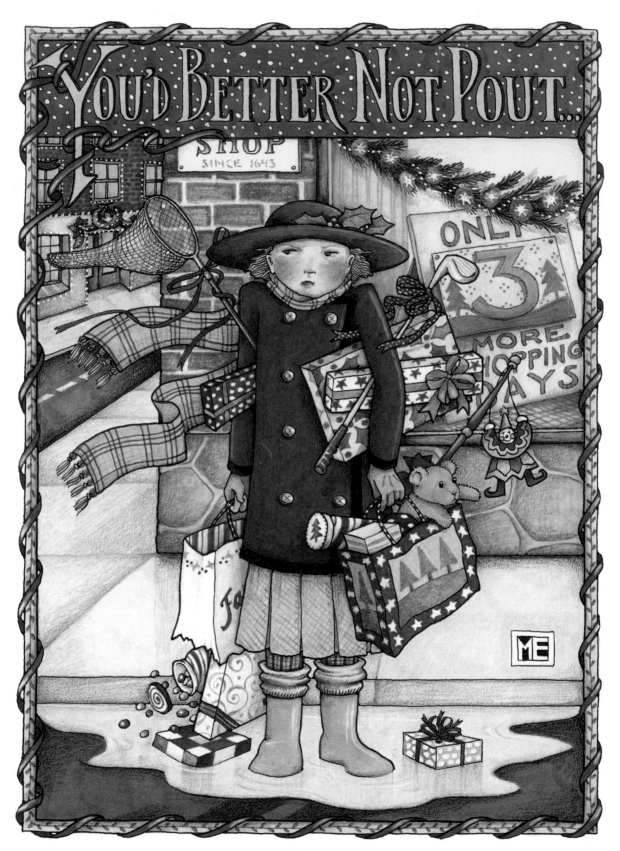

Last Minute Shopper

Lolita Pinney

Do your Christmas shopping early
Is advice I would ignore—
Let who will do autumn shopping,
I love late shopping more!

Just to see the stores a-twinkle
In their holiday array,
And to watch a child in Toyland
As he stops to dream and play;

Then to hear the sidewalk Santas
With their kettles and brass bell
Stirs one's heart to thoughts of sharing
As it whispers, "all is well!"

To choose a gift for someone
With some star dust in your eyes
Makes you eager for its giving,
For it's new—and a surprise!

Merry greetings are contagious
As you elbow through the throng;
Starry snowflakes stud your footsteps
As the wind blows clean and strong.

Let who will do Christmas shopping
On a sunny autumn day—
But for me last minute buying
Is the only joyful way!

Jest 'Fore Christmas

Eugene Field

Father calls me William, sister calls me Will,
Mother calls me Willie, but the fellers call me Bill!
Mighty glad I ain't a girl—ruther be a boy,
Without them sashes, curls, an' things that's worn by Fauntleroy!
Love to chawnk green apples an' go swimmin' in the lake—
Hate to take the castor-ile they give for belly-ache!
'Most all the time, the whole year round, there ain't no flies on me,
But jest 'fore Christmas I'm as good as I kin be!

Got a yeller dog named Sport, sick him on the cat;
First thing she knows she doesn't know where she is at!
Got a clipper sled, an' when us kids goes out to slide,
'Long comes the grocery cart, an' we all hook a ride!
But sometimes when the grocery man is worrited an' cross,
He reaches at us with his whip, an' larrups up is hoss,
An' then I laff an' holler, "Oh, ye never teched me!"
But jest 'fore Christmas I'm as good as I kin be!

Gran'ma says she hopes that when I git to be a man,
I'll be a missionarer like her oldest brother, Dan,
As was et up by the cannibuls that lives in Ceylon's Isle,
Where every prospeck pleases, an' only man is vile!
But gran'ma she has never been to see a Wild West show,
Nor read the Life of Daniel Boone, or else I guess she'd know
That Buff'lo Bill an' cow-boys is good enough for me!
Excep' jest 'fore Christmas, when I'm good as I kin be!

84

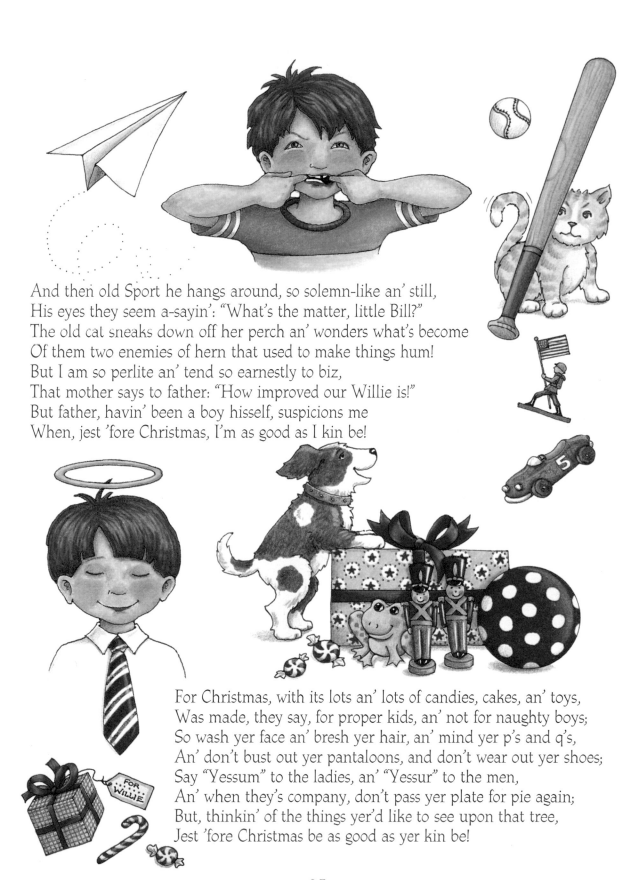

And then old Sport he hangs around, so solemn-like an' still,
His eyes they seem a-sayin': "What's the matter, little Bill?"
The old cat sneaks down off her perch an' wonders what's become
Of them two enemies of hern that used to make things hum!
But I am so perlite an' tend so earnestly to biz,
That mother says to father: "How improved our Willie is!"
But father, havin' been a boy hisself, suspicions me
When, jest 'fore Christmas, I'm as good as I kin be!

For Christmas, with its lots an' lots of candies, cakes, an' toys,
Was made, they say, for proper kids, an' not for naughty boys;
So wash yer face an' bresh yer hair, an' mind yer p's and q's,
An' don't bust out yer pantaloons, and don't wear out yer shoes;
Say "Yessum" to the ladies, an' "Yessur" to the men,
An' when they's company, don't pass yer plate for pie again;
But, thinkin' of the things yer'd like to see upon that tree,
Jest 'fore Christmas be as good as yer kin be!

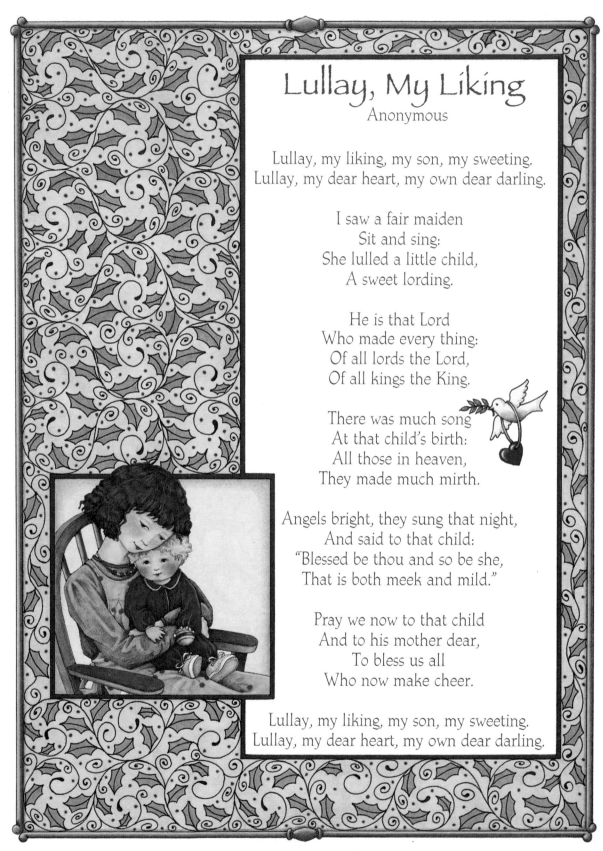

Lullay, My Liking
Anonymous

Lullay, my liking, my son, my sweeting.
Lullay, my dear heart, my own dear darling.

I saw a fair maiden
Sit and sing:
She lulled a little child,
A sweet lording.

He is that Lord
Who made every thing:
Of all lords the Lord,
Of all kings the King.

There was much song
At that child's birth:
All those in heaven,
They made much mirth.

Angels bright, they sung that night,
And said to that child:
"Blessed be thou and so be she,
That is both meek and mild."

Pray we now to that child
And to his mother dear,
To bless us all
Who now make cheer.

Lullay, my liking, my son, my sweeting.
Lullay, my dear heart, my own dear darling.

It Came Upon the Midnight Clear

Edmund Hamilton Sears and Richard Storrs Willis

It came upon the midnight clear
 That glorious song of old,
From angels bending near the earth
 To touch their harps of gold.
"Peace on the earth, goodwill to men,
 From heav'n's all-gracious King."
 The world in solemn stillness lay
 To hear the angels sing.

Still through the cloven skies they come
 With peaceful wings unfurl'd;
And still their heav'nly music floats
 O'er all the weary world.
Above its sad and lowly plains,
 They bend on hov'ring wing;
 And ever o'er its Babel sounds
 The blessed angels sing.

For lo! the days are hast'ning on,
 By prophets seen of old,
When with the ever-circling years
 Shall come the time foretold.
When the new heav'n and earth shall own
 The Prince of Peace, their King,
 And the whole of world send back the song
 Which now the angels sing.

hristmas Day in the Morning

Pearl S. Buck

He woke suddenly and completely. It was four o'clock, the hour at which his father had always called him to get up and help with the milking. Strange how the habits of his youth clung to him still! Fifty years ago, and his father had been dead for thirty years, and yet he woke at four o'clock, in the morning. He had trained himself to turn over and go to sleep, but this morning, because it was Christmas, he did not try to sleep.

Yet what was the magic of Christmas now? His childhood and youth were long past, and his own children had grown up and gone. Some of them lived only a few miles away, but they had their own families, and they would come in as usual toward the end of the day. They had explained with infinite gentleness that they wanted their children to build Christmas memories about their houses, not his. He was left alone with his wife.

Yesterday she had said, "It isn't worthwhile, perhaps—"

And he had said, "Oh, yes, Alice, even if there are only the two of us, let's have a Christmas of our own."

Then she had said, "Let's not trim the tree until tomorrow, Robert. Just so it's ready when the children come. I'm tired."

He had agreed, and the tree was still out in the back entry.

He lay in his big bed in his room. The door to her room was shut, because she was a light sleeper and sometimes he had restless nights. Years ago they had decided to use separate rooms. It meant nothing, they said, except that neither of them slept as well as they once had. They had been married so long that nothing could separate them, actually.

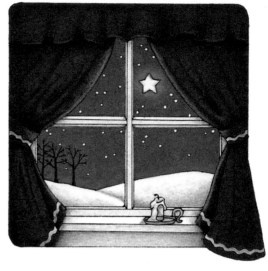

Why did he feel so awake tonight? For it was still night, a clear and starry night. No moon, of course, but the stars were extraordinary! Now that he thought of it, the stars seemed always large and clear before the dawn of Christmas Day. There was one star now that was certainly larger and brighter than any of the others. He could even imagine it moving, as it had seemed to him to move one night long ago.

He slipped back in time, as he did so easily nowadays. He was fifteen years old and still on his father's farm. He loved his father. He had not known it until one time a few days before Christmas, when he had overheard what his father was saying to his mother.

"Mary, I hate to call Rob in the mornings. He's growing so fast and he needs his sleep. If you could see how he sleeps when I go in to wake him up! I wish I could manage alone."

"Well, you can't, Adam." His mother's voice was brisk. "Besides, he isn't a child anymore. It's time he took his turn."

"Yes," his father said slowly. "But I sure do hate to wake him."

When he heard these words, something in him woke. His father loved him! He had never thought of it before, taking for granted the tie of their blood. Neither his father nor his mother talked about their

children; they had no time for such things. There was always so much to do on a farm.

Now he knew his father loved him, there would be no more loitering in the mornings and having to be called again. He got up after that, stumbling blind with sleep, and pulled on his clothes, his eyes tight shut, but he got up.

And then on the night before Christmas, that year when he was fifteen, he lay for a few minutes thinking about the next day. They were poor, and most of the excitement was in the turkey they had raised themselves and in the mince pies his mother made. His sisters sewed presents, and his mother and father always bought something he needed, not only a warm jacket, maybe, but something more, such as a book. And he saved and bought them each something too.

He wished, that Christmas he was fifteen, he had a better present for his father. As usual he had gone to the ten-cent store and bought a tie. It had seemed nice enough until he lay thinking the night before Christmas, and then he wished that he had heard his father and mother talking in time for him to save for something better.

He lay on his side, his head supported by his elbow, and looked out his attic window. The stars were bright, much brighter than he ever remembered seeing them, and one star in particular was so bright that he wondered if it were really the Star of Bethlehem.

"Dad," he had once asked, when he was a little boy, "what is a stable?"

"It's just a barn," his father had replied, "like ours."

Then Jesus had been born in a barn, and to a barn the shepherds and the Wise Men had come, bringing their Christmas gifts!

The thought had struck him like a silver dagger. Why should he not give his father a special gift too, out there in the barn? He could get up early, earlier than four o'clock, and he could creep into the barn and

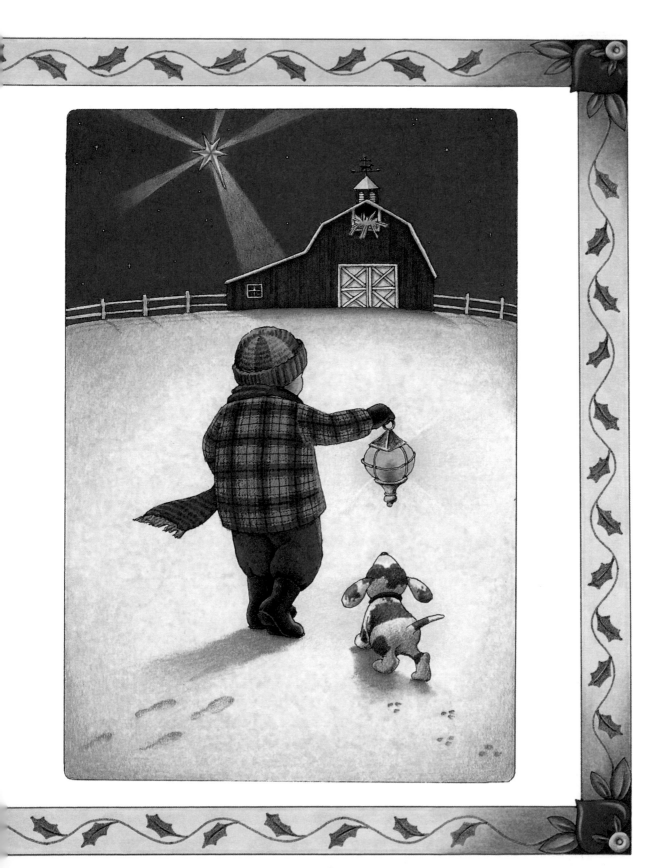

get all the milking done. He'd do it alone, milk and clean up, and then when his father went in to start the milking he'd see it all done. And he could know who had done it.

He laughed to himself as he gazed at the stars. It was what he would do, and he mustn't sleep too sound.

He must have waked twenty times, scratching a match each time to look at his old watch—midnight, and half past one, and then two o'clock.

At a quarter to three he got up and put on his clothes. He crept downstairs, careful of the creaky boards, and let himself out. The big star hung lower over the barn roof, a reddish gold. The cows looked at him, sleepy and surprised. It was early for them too.

"So, boss," he whispered. They accepted him placidly, and he fetched some hay for each cow, and then got the milking pail and the big milk cans.

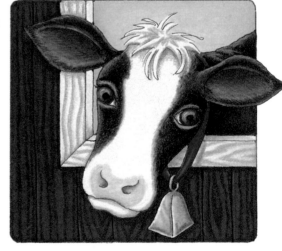

He had never milked all alone before, but it seemed almost easy. He kept thinking about his father's surprise. His father would come in and call him, saying that he would get things started while Rob was getting dressed. He'd go to the barn, open the door, and then he'd go to get the two big empty milk cans. But they wouldn't be waiting or empty; they'd be standing in the milkhouse, filled.

"What the—" he could hear his father exclaiming.

He smiled and milked steadily, two strong streams rushing into the pail, frothing and fragrant. The cows were still surprised but acqui-

escent. For once they were behaving well, as though they knew it was Christmas.

The task went more easily than he had ever known it to before. Milking for once was not a chore. It was something else, a gift to his father, who loved him. He finished, the two milk cans were full, and he covered them and closed the milkhouse door carefully, making sure of the latch. He put the stool in its place by the door and hung up the clean milk pail. Then he went out of the barn and barred the door behind him.

Back in his room he had only a minute to pull off his clothes in the darkness and jump into bed, for he heard his father up. He put the covers over his head to silence his quick breathing. The door opened.

"Rob!" his father called. "We have to get up, son, even if it is Christmas."

"Aw right," he said sleepily.

"I'll go on out," his father said. "I'll get things started." The door closed and he lay still, laughing to himself. In just a few minutes his father would know. His dancing heart was ready to jump from his body.

The minutes were endless—ten, fifteen, he did not know how many—before he heard his father's footsteps again. The door opened and he lay still.

"Rob!"

"Yes, Dad—"

"You son of a—" His father was laughing, a queer, sobbing sort of laugh. "Thought you'd fool me, did you?" His father was standing beside his bed, feeling for him, pulling away the cover.

"It's for Christmas, Dad!"

He found his father and clutched him in a great hug. He felt his father's arms go around him. It was dark and they could not see each other's faces.

"Son, I thank you. Nobody ever did a nicer thing—"

"Oh, Dad, I want you to know—I do want to be good!" The words broke from him of their own will. He did not know what to say. His heart was bursting with love.

"Well, I reckon I can go back to bed and sleep," his father said after a moment. "No, hark, the little ones are waked up. Come to think of it, son, I've never seen you children when you first saw the Christmas tree. I was always in the barn. Come on!"

He got up and pulled on his clothes again, and they went down to the Christmas tree, and soon the sun was creeping up to where the star had been. Oh, what a Christmas, and how his heart had nearly burst again with shyness and pride as his father told his mother and made the younger children listen about how he, Rob, had got up all by himself.

"The best Christmas gift I ever had, and I'll remember it, son, every year on Christmas morning, so long as I live."

They had both remembered it, and now that his father was dead he remembered it alone, that blessed Christmas dawn when, alone with the cows in the barn, he had made his first gift of true love.

Outside the window now the great star slowly sank. He got up out of bed and put on his slippers and bathrobe and went softly upstairs to the attic and found the box of Christmas-tree decorations. He took them downstairs into the living room. Then he brought in the tree. It was a little one—they had not had a big tree since the children went away—but he set it in the holder and put it in the middle of the long table under the window. Then carefully he began to trim it.

It was done very soon, the time passing as quickly as it had that morning long ago in the barn. He went to his library and fetched the little box that contained his special gift to his wife, a star of diamonds, not large but dainty in design. He had written the card for it the day before.

He tied the gift on the tree and then stood back. It was pretty, very pretty, and she would be surprised.

But he was not satisfied. He wanted to tell her, to tell her how much he loved her. It had been a long time since he had really told her, although he loved her in a very special way, much more than he ever had when they were young.

He had been fortunate that she had loved him, and how fortunate that he had been able to love! Ah, that was the true joy of life, the ability to love! For he was quite sure that some people were genuinely unable to love anyone. But love was alive in him; it still was.

It occurred to him suddenly that it was alive because long ago it had been born in him when he knew his father loved him. That was it: love alone could waken love.

And he could give the gift again and again. This morning, this blessed Christmas morning, he would give it to his beloved wife. He could write it down in a letter for her to read and keep forever. He went to his desk and began his love letter to his wife: "My dearest love...."

When it was finished he sealed it and tied it on the tree where she would see it the first thing when she came into the room. She would read it, surprised and then moved, and realize how very much he loved her.

He put out the light and went tiptoeing up the stairs. The star in the sky was gone, and the first rays of the sun were gleaming the sky. Such a happy, happy Christmas!

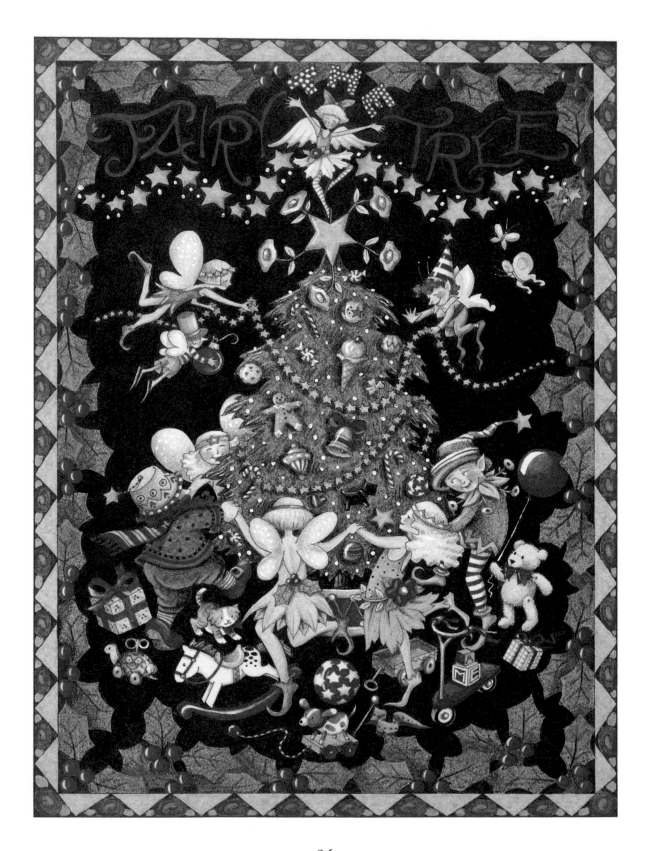

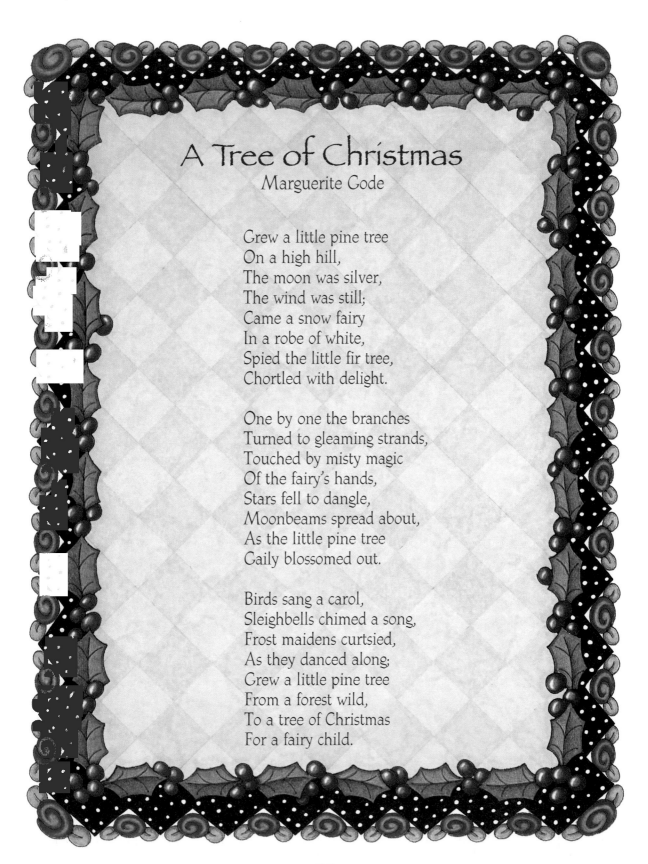

A Tree of Christmas

Marguerite Gode

Grew a little pine tree
On a high hill,
The moon was silver,
The wind was still;
Came a snow fairy
In a robe of white,
Spied the little fir tree,
Chortled with delight.

One by one the branches
Turned to gleaming strands,
Touched by misty magic
Of the fairy's hands,
Stars fell to dangle,
Moonbeams spread about,
As the little pine tree
Gaily blossomed out.

Birds sang a carol,
Sleighbells chimed a song,
Frost maidens curtsied,
As they danced along;
Grew a little pine tree
From a forest wild,
To a tree of Christmas
For a fairy child.

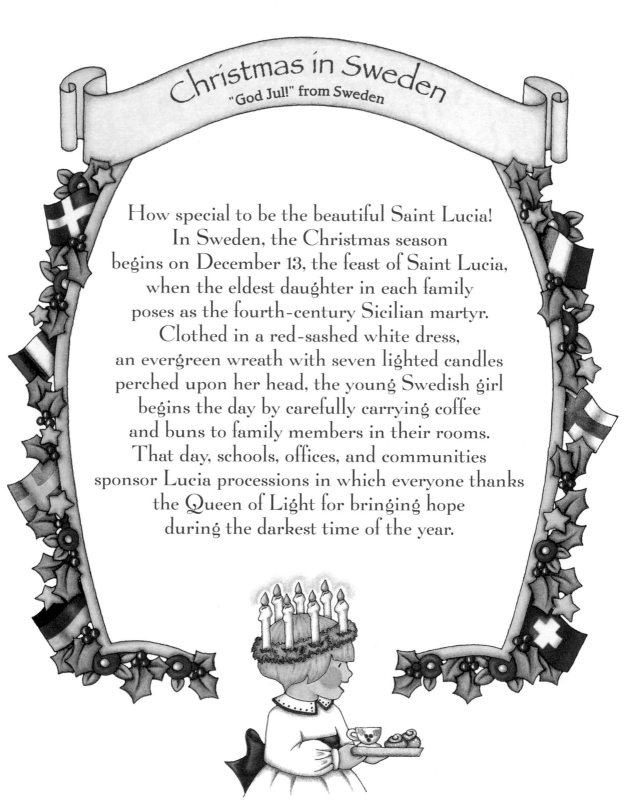

Christmas in Sweden

"God Jul!" from Sweden

How special to be the beautiful Saint Lucia!
In Sweden, the Christmas season
begins on December 13, the feast of Saint Lucia,
when the eldest daughter in each family
poses as the fourth-century Sicilian martyr.
Clothed in a red-sashed white dress,
an evergreen wreath with seven lighted candles
perched upon her head, the young Swedish girl
begins the day by carefully carrying coffee
and buns to family members in their rooms.
That day, schools, offices, and communities
sponsor Lucia processions in which everyone thanks
the Queen of Light for bringing hope
during the darkest time of the year.

The Stork

The Stork she rose on Christmas Eve
And said unto her brood,
I now must fare to Bethlehem
To view the Son of God.

She gave to each his dole of meat,
She stowed them fairly in,
And fair she flew and fast she flew,
And came to Bethlehem.

Now where is He of David's line?
She asked at house and hall,
He is not here, they spake hardly,
But in the manger stall.

She found Him in the manger stall
With that most holy maid;
The gentle Stork she wept to see
The Lord so rudely laid.

Then from her panting breast she plucked
The feathers white and warm;
She strewed them in the manger bed
To keep the Lord from harm.

Now blessed be the gentle Stork
Forever more quoth He,
For that she saw my sad estate,
And showed pity.

Full welcome shall she ever be
In hamlet and in hall,
And called henceforth the Blessed Bird
And friend of babies all.

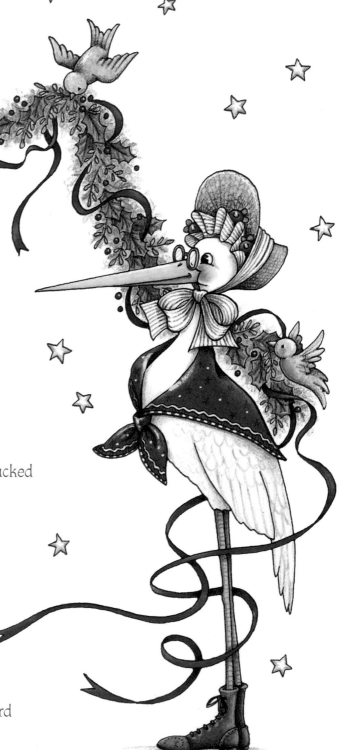

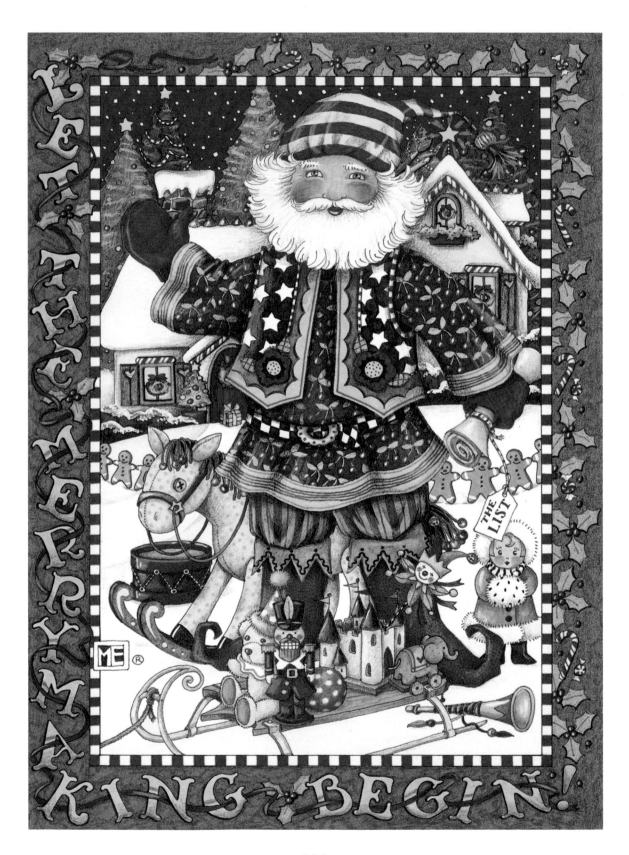

LET THE MERRY MAKING BEGIN!

THE LIST

100

Christmas Comes But Once a Year

Thomas Miller

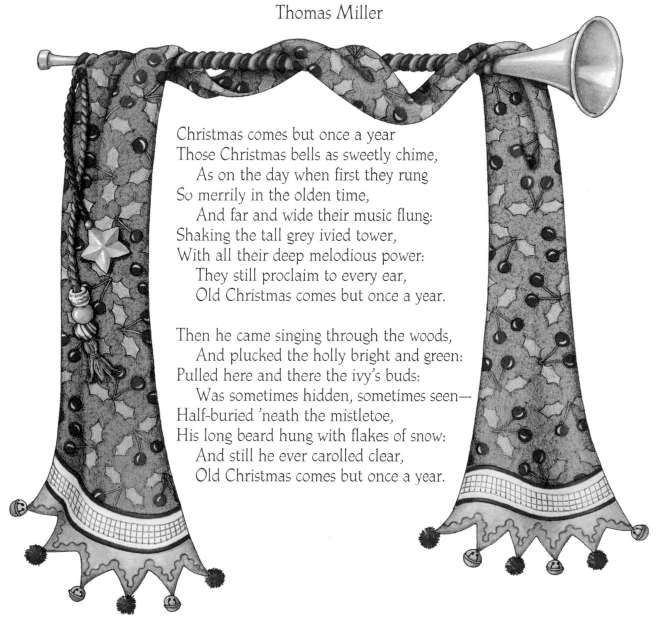

Christmas comes but once a year
Those Christmas bells as sweetly chime,
 As on the day when first they rung
So merrily in the olden time,
 And far and wide their music flung:
Shaking the tall grey ivied tower,
With all their deep melodious power:
 They still proclaim to every ear,
 Old Christmas comes but once a year.

Then he came singing through the woods,
 And plucked the holly bright and green:
Pulled here and there the ivy's buds:
 Was sometimes hidden, sometimes seen—
Half-buried 'neath the mistletoe,
His long beard hung with flakes of snow:
 And still he ever carolled clear,
 Old Christmas comes but once a year.

Christmas time! That man must be a misanthrope indeed, in

whose breast something like a jovial feeling is not roused—in whose mind
some pleasant associations are not awakened—by the recurrence of Christmas.
There are people who will tell you that Christmas is not to them what it
used to be. . . . Never heed such dismal reminiscences. There are few men who
have lived long enough in the world, who cannot call up such thoughts
any day in the year. Then do not select the merriest of the three hundred
and sixty-five, for your doleful recollections, but draw your chair nearer
the blazing fire—fill the glass and send round the song . . . and thank God
it's no worse. . . . Reflect upon your present blessings—of which every man
has many—not on your past misfortunes, of which all men have some.
Fill your glass again, with a merry face and contented heart. Our life on it,
but your Christmas shall be merry, and your new year a happy one!

Charles Dickens

The Queen's Tree
from the *Illustrated London News*, 1848

The Christmas tree is annually prepared by her Majesty's command for the Royal children. . . . The tree employed for this festive purpose is a young fir of about eight feet high, and has six tiers of branches. On each tier, or branch, are arranged a dozen wax tapers. Pendant from the branches are elegant trays, baskets, *bonbonnières,* and other receptacles for sweetmeats of the most varied and expensive kind; and of all forms, colours, and degrees of beauty. Fancy cakes, gilt gingerbread and eggs filled with sweetmeats, are also suspended by variously-coloured ribbons from the branches. The tree, which stands upon a table covered with white damask, is supported at the root by piles of sweets of a larger kind, and by toys and dolls of all descriptions, suited to the youthful fancy. . . . On the summit of the tree stands the small figure of an angel, with outstretched wings, holding in each hand a wreath.

It is a comely fashion to be glad;
Joy is the grace we say to God.

Jean Ingelow

Peace was the first thing the angels sang.
Peace is the mark of the sons of God.
Peace is the nurse of love.
Peace is the mother of unity.
Peace is the rest of blessed souls.
Peace is the dwelling place of eternity.

Leo the Great

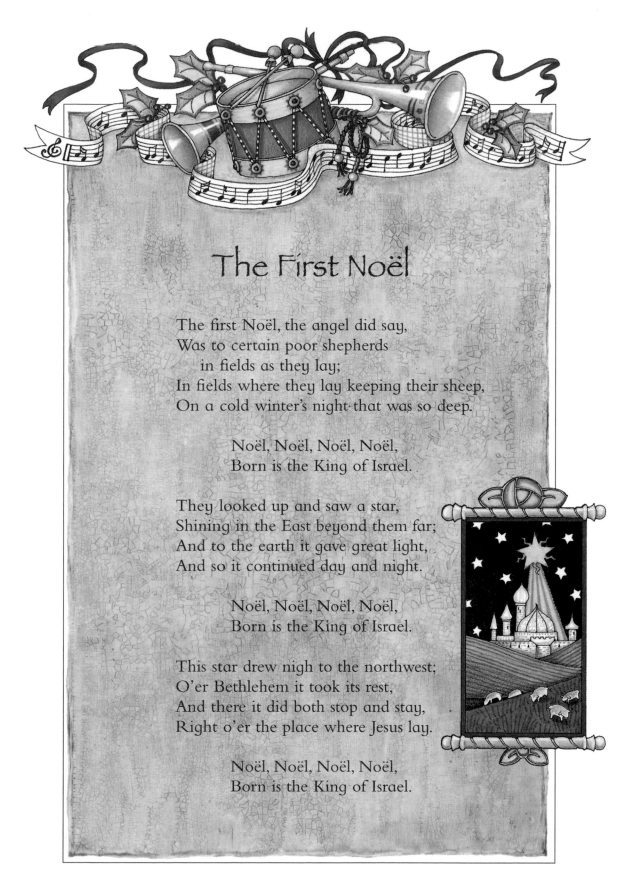

The First Noël

The first Noël, the angel did say,
Was to certain poor shepherds
 in fields as they lay;
In fields where they lay keeping their sheep,
On a cold winter's night that was so deep.

 Noël, Noël, Noël, Noël,
 Born is the King of Israel.

They looked up and saw a star,
Shining in the East beyond them far;
And to the earth it gave great light,
And so it continued day and night.

 Noël, Noël, Noël, Noël,
 Born is the King of Israel.

This star drew nigh to the northwest;
O'er Bethlehem it took its rest,
And there it did both stop and stay,
Right o'er the place where Jesus lay.

 Noël, Noël, Noël, Noël,
 Born is the King of Israel.

The Three Skaters

Anonymous

It was a cold, barren winter that year. The harvest had been poor; the barns were only half filled. The farmers wondered how they would be able to pull through the winter, how they were to feed their hungry families and their cattle, how to heat their homes.

A stillness hung over the wide, cold Dutch land, a tense stillness. Low gray clouds hung heavy over the snowy white fields. Along the canals, stretching straight and frozen till they faded out in the distant horizon, the gnarled willows stood in ragged rows like awkward onlookers.

A farmer skated home over the frozen canal. He had been to market that day, and all he had been able to get for his few pennies was a bagful of red apples, which he carried over his shoulder. He hunched his back against the icy wind and hurried along with long, steady strokes, thinking all the while how disappointed his wife and the children would be with the meager results of his marketing.

He stopped for a moment to refasten his curved wooden skates. As he stood there catching his breath, he thought he heard a soft,

swishing sound in the distance. Looking up and peering through the mist, he saw his neighbor the old miller appear through the falling dusk. His back was bent under a load of bread which he had gotten from the baker in exchange for his flour. The two men greeted each other without a word, and they went on through the silent evening, each sunk in his own thoughts, each knowing that the other man's thoughts were similar to his own.

They halted at a little drawbridge, too low to pass under. With uncertain, clumsy feet on skates they stepped on land to cross to the other side of the bridge. Just as they found themselves back on the canal they were joined by another neighbor, a pig farmer who carried a side of bacon which no one had been willing to buy from him.

The three silent men hurried on, the strong, regular strokes of their skates the only sounds in the wide, wintry landscape. There should be a moon somewhere; at least the heavy clouds looked strangely lit as if by an inner light. It had become even colder now, and the men huddled deeper into their woolen mufflers. The old miller lagged somewhat behind. He felt tired, and he shifted the heavy sack from his left to his right shoulder. As he looked up he saw that the moon had appeared from behind the clouds. One cold, stark beam pointed straight down on an old barn across the snow-covered field on the left.

Suddenly a sound came from that lonely barn, a sound as if from a baby crying. "Hey!" the miller called his companions. "Hey, there—stop! Come over here!"

The other two men braked to a halt and turned around slowly, annoyed at the old man. It was cold and late, and they wanted to go home.

"Listen," said the miller, pointing his finger to the old barn. There was no mistake—they heard it too. There was a baby crying in that barn.

"But there ain't nobody living there," said the farmer. "That barn's been empty for years, ever since the old man built himself a new one next to his house."

"He keeps his sheep there," said the pig farmer, "but that sound comes from no sheep."

For a moment the three men looked at each other. Then all three removed their skates and stepped on land to find out.

As they neared the moonlit barn the crying became quieter, a mere whimper now, while a gentle woman's voice began softly to hum a little tune. The three neighbors shook their heads, completely baffled. They hesitated for just a second; then the miller moved forward and opened the barn door. All three stepped inside.

They had to become accustomed to the darkness at first, away from the clear shaft of moonlight. But as their eyes adjusted themselves to the dim glow of the lantern inside, they saw that their ears had not deceived them. As if by common impulse, all three took off their caps.

A young woman, whom they had never seen before, sat there on the cold barn floor. In her arms she held a newly born baby, which she rocked gently to and fro. She had wrapped her coat around the little boy, who was now sleeping peacefully. An older man was raking some hay together in a corner near where the sheep stood, and the mother laid down her baby tenderly on that one little heap of softness in the cold, rough barn.

"We come from far away," the old man began to explain, as if to answer unspoken questions, "and we shall have far to go. When it was time for my wife to have the baby, we tried very hard to find shelter, and we are grateful that we could get this barn. But we can't stay long, for we have no food and no firewood. We shall have to move on tomorrow. . . ."

The three men just stood there, not speaking, turning their caps

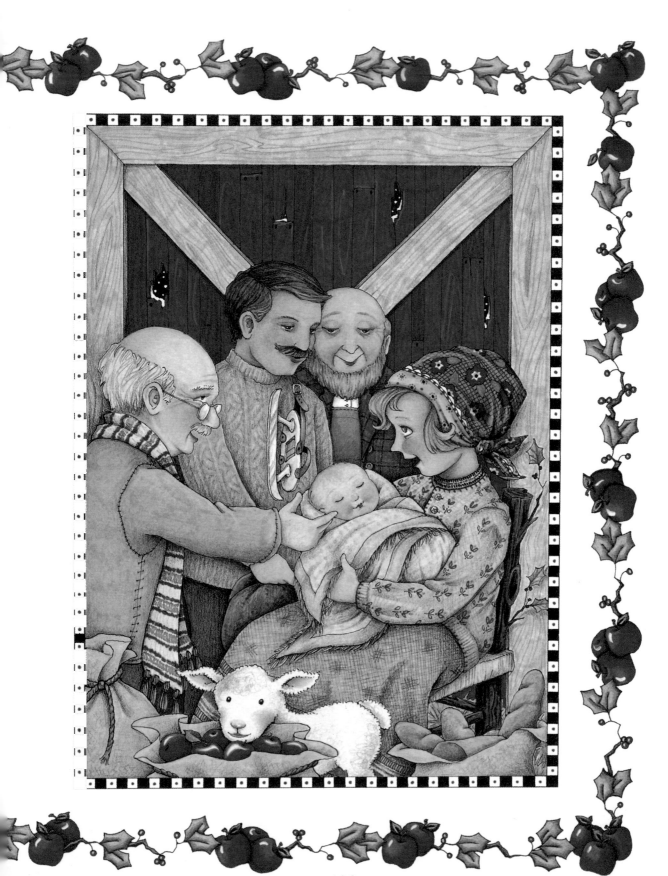

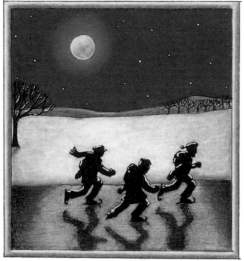

in their hands. Then, driven as by a single force, each of them lowered the sack from his shoulder and emptied it before the young mother. The apples, the bread, and the bacon gleamed curiously in the flickering lantern light. Her eyes looked at them with such quiet peace and acceptance that they felt a strange sense of well-being, which made them almost uneasy at the same time. One by one they took a look at the sleeping little boy, then turned around and left, gently closing the barn door behind them.

It had become still colder now, but the clouds had disappeared and the moon shone brightly over the snow-covered landscape. The men put their caps back on, knotted the mufflers tightly around their necks, and flung their empty bags across their shoulders. Back at the canal, they fastened their skates and started on the last stretch home, each thinking about the little scene they had just witnessed.

One—two, one—two, went the skates over the frozen waterway. It was strange, but none of them seemed to feel worried about coming home empty-handed. Somehow life seemed to hold so much in store for them. They felt almost lighthearted, skating there in the clear frosty night. Yet it was as if the empty sacks they carried were getting heavier and heavier, as if somebody dropped a stone into them with every stroke they made. By the time they had reached their village and had removed their skates, they were pretty near bent double under the load they carried. They could not explain it, but somehow they knew that it was good.

At the church the three men parted; the farmer, the miller, and

the pig farmer each went his own way, back to his family. The last few steps seemed almost unbearable, so heavy was the weight on their shoulders. As each opened his back door and entered his home, he dumped the sack on the floor and looked at the expectant faces around the fireplace with its blue and white tiles.

Loud cheers went up. "Father!" "Here is Father!" "Father is home!" All the youngsters jumped up and began to pull at the strings of the bags, pushing each other, laughing, romping, as if this were a new kind of game.

Oh, the wonder of it all! When the bags were finally opened and turned out over the kitchen floors, an abundance of food rolled over the neatly scrubbed tiles. And there weren't merely everyday things. There was candy for the children, Dutch honey cake for the mothers, and also tobacco for the fathers. What a feast there was in the three homes!

When all was quiet again each of the three men sat down by his fireplace, contentedly puffing his pipe. But in spirit the three were far away. . . . Their thoughts hovered around a moonlit barn, around a simple little lantern-lit scene where a miracle had come to pass.

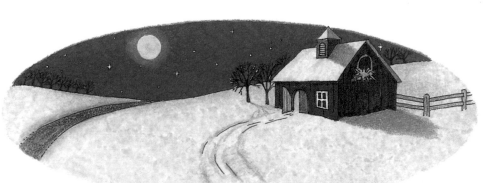

REMEMBRANCE, LIKE A CANDLE····· BURNS BRIGHTEST AT CHRISTMAS TIME

C. DICKENS

ME 19·85 C

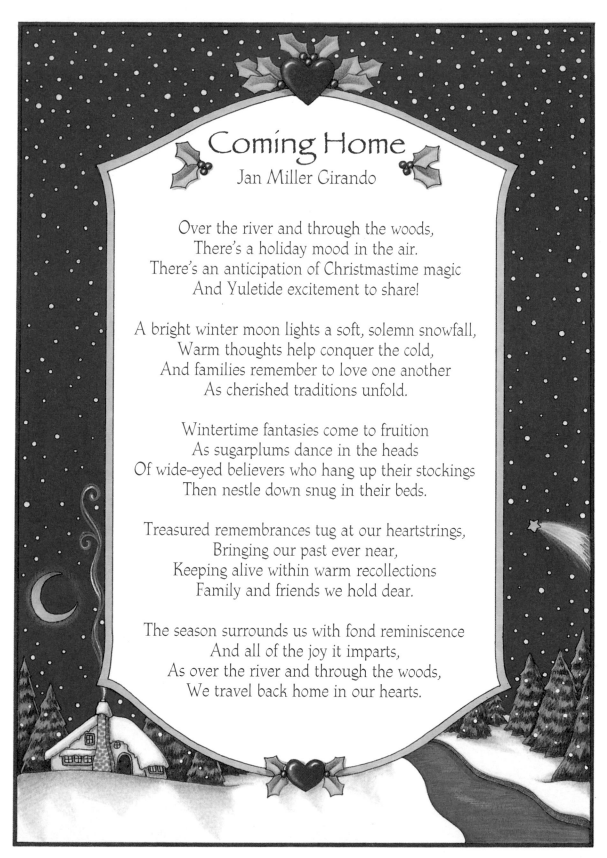

Coming Home

Jan Miller Girando

Over the river and through the woods,
There's a holiday mood in the air.
There's an anticipation of Christmastime magic
And Yuletide excitement to share!

A bright winter moon lights a soft, solemn snowfall,
Warm thoughts help conquer the cold,
And families remember to love one another
As cherished traditions unfold.

Wintertime fantasies come to fruition
As sugarplums dance in the heads
Of wide-eyed believers who hang up their stockings
Then nestle down snug in their beds.

Treasured remembrances tug at our heartstrings,
Bringing our past ever near,
Keeping alive within warm recollections
Family and friends we hold dear.

The season surrounds us with fond reminiscence
And all of the joy it imparts,
As over the river and through the woods,
We travel back home in our hearts.

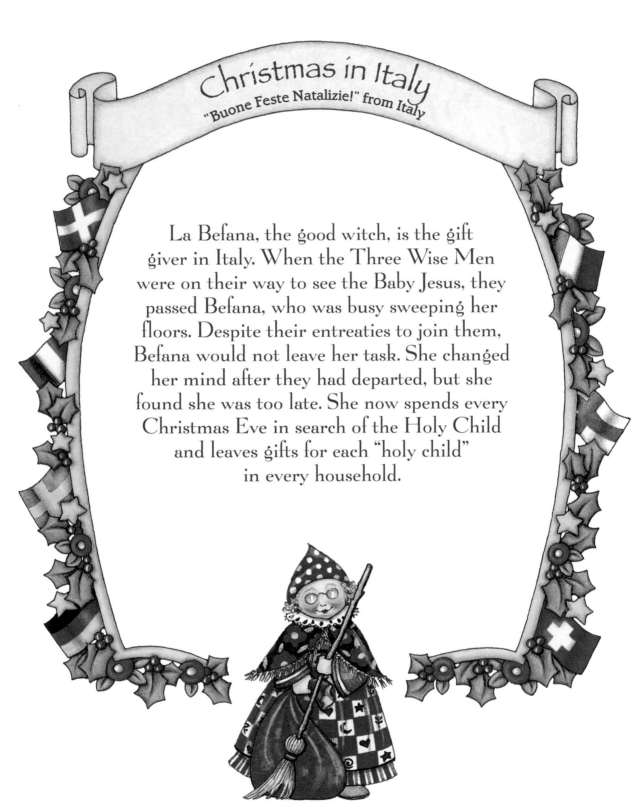

Christmas in Italy

"Buone Feste Natalizie!" from Italy

La Befana, the good witch, is the gift giver in Italy. When the Three Wise Men were on their way to see the Baby Jesus, they passed Befana, who was busy sweeping her floors. Despite their entreaties to join them, Befana would not leave her task. She changed her mind after they had departed, but she found she was too late. She now spends every Christmas Eve in search of the Holy Child and leaves gifts for each "holy child" in every household.

"Well, Mr. Arbuthnot, I'm a thousand times obliged to you. I didn't realize there were so many Christmas clichés."

"Son, Christmas is full of them—good, wholesome, warming clichés that soften, if only for a few days, the bitterness and heartache that fill the world. Clichés about holly and mistletoe and Yule logs and wassail, and Tiny Tims and Scrooges, about people thinking about other people for a change, about Christmas vacations and families reunited, about churchgoers leaving midnight Mass and calling cheery greetings to one another as they hurry home through the friendly snow to trim the trees, about goodwill to men—yes, and about peace on earth and the hope of it. My boy, 'Merry Christmas' is the noblest and kindliest cliché that ever was, and if the day should come when men will no longer have the heart to wish their neighbors a Merry Christmas and a Happy New Year, on that day the human race will have real reason to despair."

Frank Sullivan

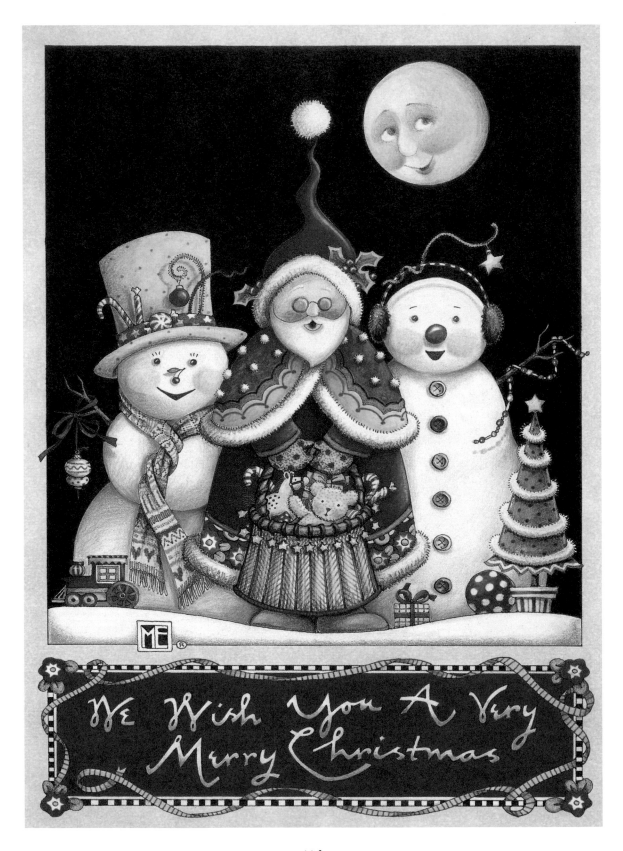

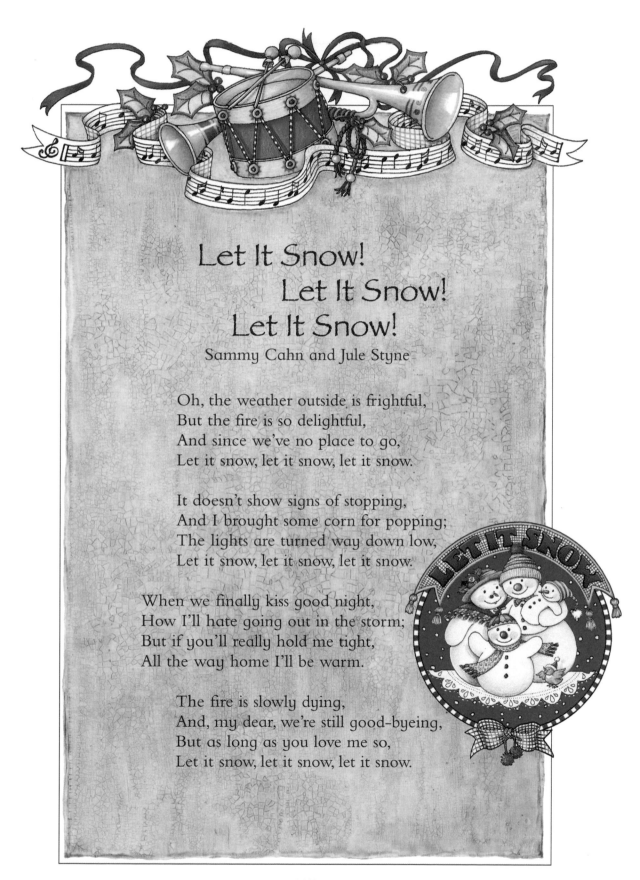

Let It Snow!
Let It Snow!
Let It Snow!

Sammy Cahn and Jule Styne

Oh, the weather outside is frightful,
But the fire is so delightful,
And since we've no place to go,
Let it snow, let it snow, let it snow.

It doesn't show signs of stopping,
And I brought some corn for popping;
The lights are turned way down low,
Let it snow, let it snow, let it snow.

When we finally kiss good night,
How I'll hate going out in the storm;
But if you'll really hold me tight,
All the way home I'll be warm.

The fire is slowly dying,
And, my dear, we're still good-byeing,
But as long as you love me so,
Let it snow, let it snow, let it snow.

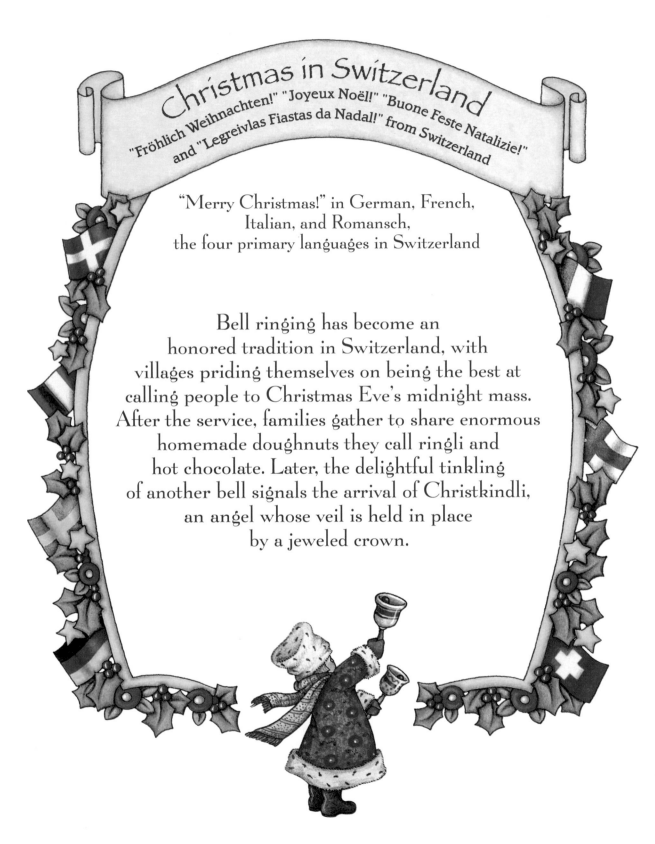

Christmas in Switzerland

"Fröhlich Weihnachten!" "Joyeux Noël!" "Buone Feste Natalizie!"
and "Legreivlas Fiastas da Nadal!" from Switzerland

"Merry Christmas!" in German, French,
Italian, and Romansch,
the four primary languages in Switzerland

Bell ringing has become an
honored tradition in Switzerland, with
villages priding themselves on being the best at
calling people to Christmas Eve's midnight mass.
After the service, families gather to share enormous
homemade doughnuts they call ringli and
hot chocolate. Later, the delightful tinkling
of another bell signals the arrival of Christkindli,
an angel whose veil is held in place
by a jeweled crown.

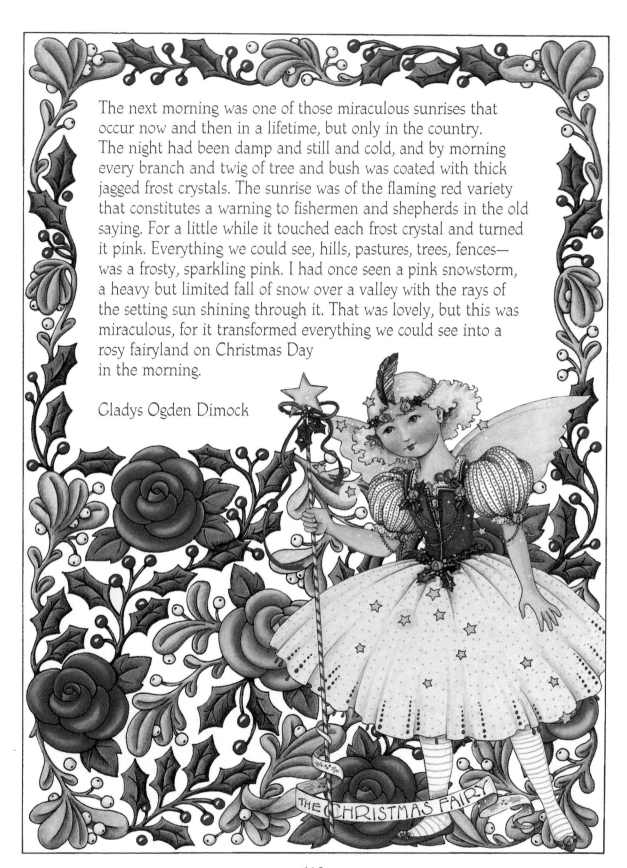

The next morning was one of those miraculous sunrises that
occur now and then in a lifetime, but only in the country.
The night had been damp and still and cold, and by morning
every branch and twig of tree and bush was coated with thick
jagged frost crystals. The sunrise was of the flaming red variety
that constitutes a warning to fishermen and shepherds in the old
saying. For a little while it touched each frost crystal and turned
it pink. Everything we could see, hills, pastures, trees, fences—
was a frosty, sparkling pink. I had once seen a pink snowstorm,
a heavy but limited fall of snow over a valley with the rays of
the setting sun shining through it. That was lovely, but this was
miraculous, for it transformed everything we could see into a
rosy fairyland on Christmas Day
in the morning.

Gladys Ogden Dimock

THE CHRISTMAS FAIRY

For Christmas
Rachel Field

Now not a window small or big
But wears a wreath or holly sprig;
Nor any shop too poor to show
Its spray of pine or mistletoe.
Now city airs are spicy-sweet
With Christmas trees along each street,
Green spruce and fir whose boughs will hold
Their tinseled balls and fruits of gold.
Now postmen pass in threes and fours
Like bent, blue-coated Santa Claus.
Now people hurry to and fro
With little girls and boys in tow,
And not a child but keeps some trace
Of Christmas secrets in his face.

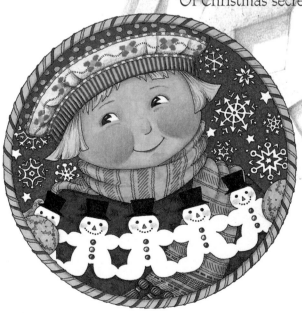

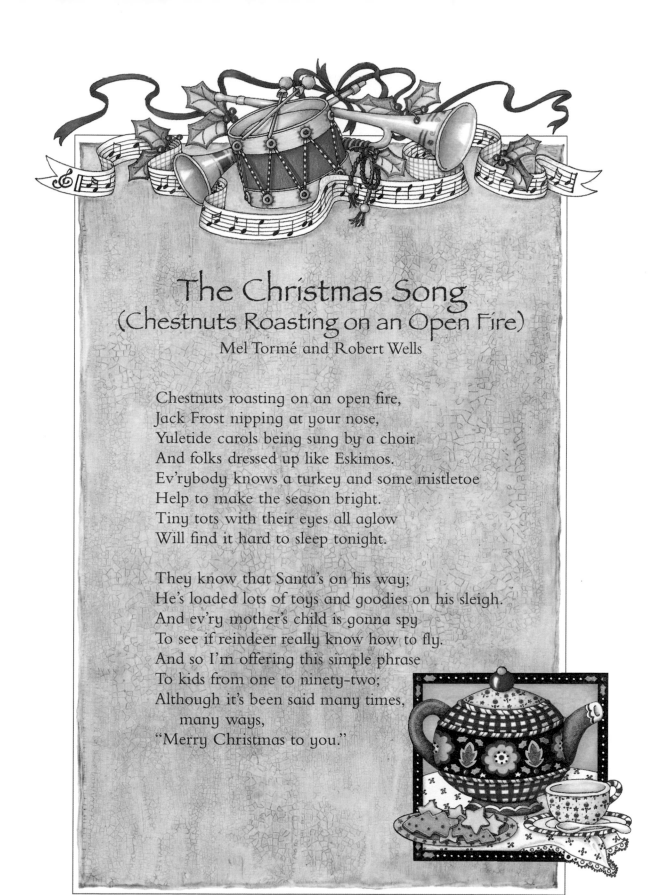

The Christmas Song
(Chestnuts Roasting on an Open Fire)
Mel Tormé and Robert Wells

Chestnuts roasting on an open fire,
Jack Frost nipping at your nose,
Yuletide carols being sung by a choir.
And folks dressed up like Eskimos.
Ev'rybody knows a turkey and some mistletoe
Help to make the season bright.
Tiny tots with their eyes all aglow
Will find it hard to sleep tonight.

They know that Santa's on his way;
He's loaded lots of toys and goodies on his sleigh.
And ev'ry mother's child is gonna spy
To see if reindeer really know how to fly.
And so I'm offering this simple phrase
To kids from one to ninety-two;
Although it's been said many times,
 many ways,
"Merry Christmas to you."

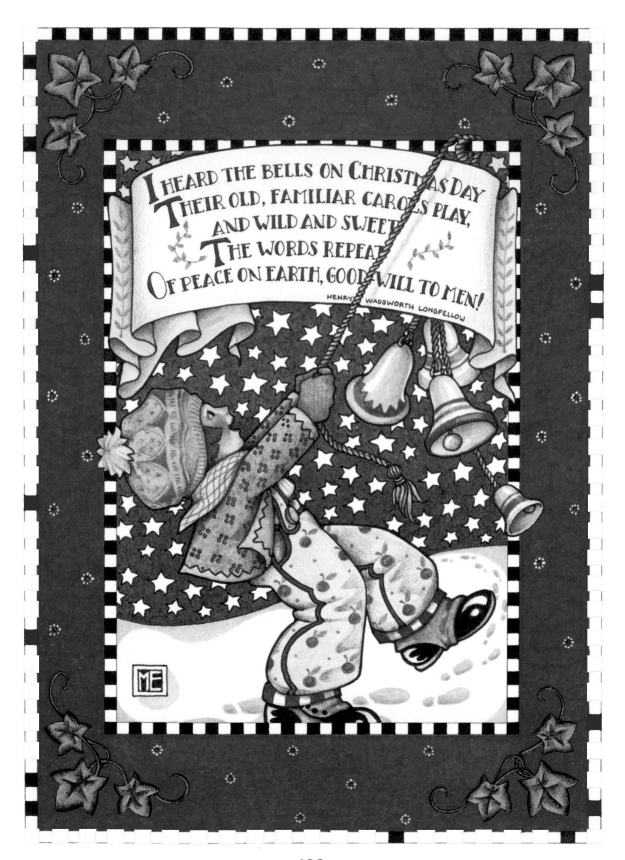

I HEARD THE BELLS ON CHRISTMAS DAY
THEIR OLD, FAMILIAR CAROLS PLAY,
AND WILD AND SWEET
THE WORDS REPEAT
OF PEACE ON EARTH, GOOD-WILL TO MEN!

HENRY WADSWORTH LONGFELLOW

'Tis the Season
Jan Miller Girando

'Tis the season to be jolly—
 to enjoy the Yuletide gladness
 as the time till Christmas morning ticks away,
And to take a special pleasure
 in the colorful traditions
 that make Christmas such a special holiday!

'Tis the season to be jolly
 as we shop for perfect presents,
 that we fondly hope are tailor-made to please,
And to share a cup of eggnog
 with our friends and with our families
 in the splendor of their tinsel-tinted trees!

Time to make a list for Santa
 or to write a nice, long letter
 making certain our desires are understood.
Surely Santa is aware of
 our exemplary behavior,
 and will bring us a reward for being good!

'Tis the time to be an angel
 and to watch for Santa's helpers
 as with elfin glee they scamper to and fro,
Wrapping last-minute surprises,
 helping Santa to prepare for
 his exciting midnight journey through the snow!

'Tis a time for celebration
 in the company of others
 and a time for making magic now and then.
'Tis a playful time, a fun-filled time,
 a time of warmth and wonder—
 'tis the season to be jolly once again!

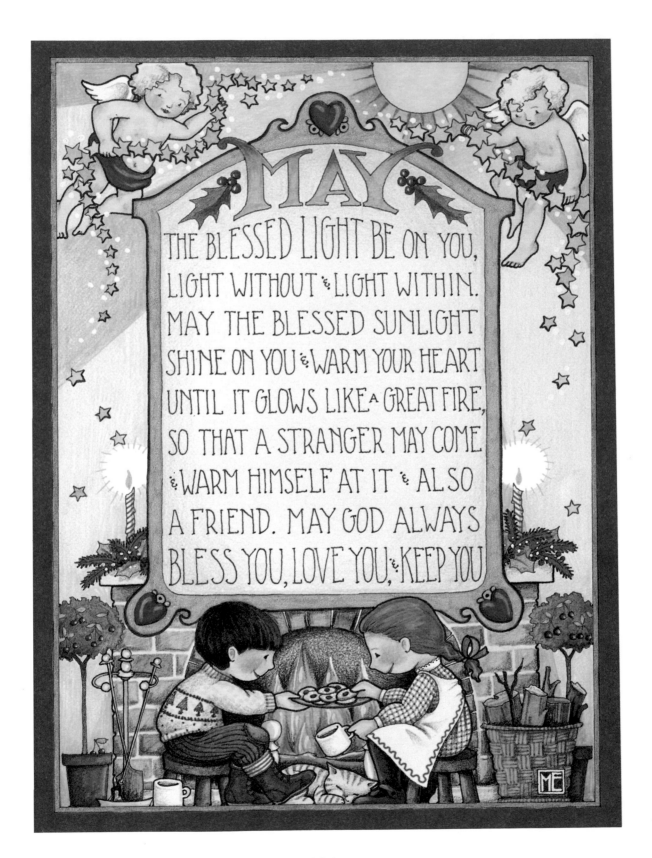

MAY

THE BLESSED LIGHT BE ON YOU, LIGHT WITHOUT & LIGHT WITHIN. MAY THE BLESSED SUNLIGHT SHINE ON YOU & WARM YOUR HEART UNTIL IT GLOWS LIKE A GREAT FIRE, SO THAT A STRANGER MAY COME & WARM HIMSELF AT IT & ALSO A FRIEND. MAY GOD ALWAYS BLESS YOU, LOVE YOU, & KEEP YOU

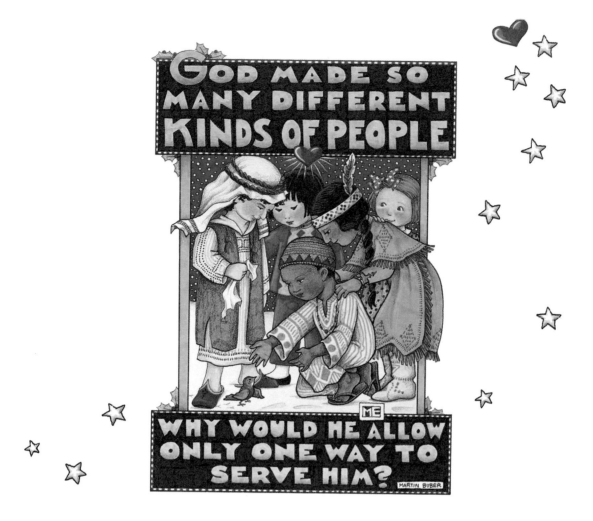

Let everyone be himself, and not try to be someone else. God, who looked on the world He had made and said it was all good, made each of us to be just what our own gifts and faculties fit us to be. Be that and do that and so be contented. Reverence, also, each other's gifts; do not quarrel with me because I am not you, and I will do the same. God made your brother as well as yourself.

He made you, perhaps, to be bright; he made him slow; he made you practical; he made him speculative; he made one strong and another weak, one tough and another tender; but the same God made us all. Let us not torment each other because we are not all alike, but believe that God knew best what he was doing in making us so different. So will the best harmony come out of seeming discords, the best affection out of differences, the best life out of struggle, and the best work will be done when each does his own work, and lets everyone else do and be what God made him for.

James Freeman Clarke

125

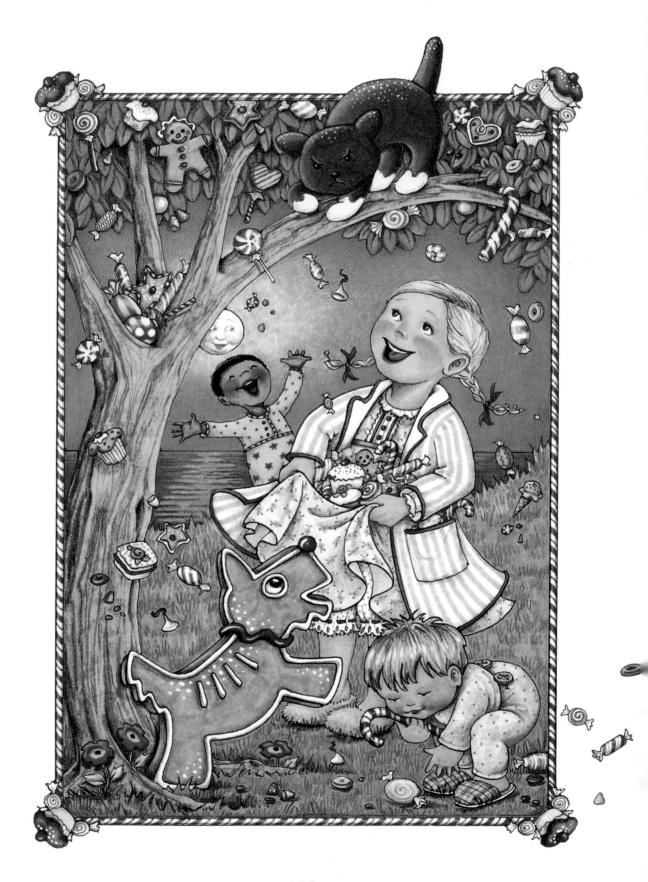

The Sugar-Plum Tree

Eugene Field

Have you ever heard of the Sugar-Plum Tree?
 'Tis a marvel of great renown!
It blooms on the shore of the Lollipop sea
 In the garden of Shut-Eye Town;
The fruit that it bears is so wondrously sweet
 (As those who have tasted it say)
That good little children have only to eat
 Of that fruit to be happy next day.

When you've got to the tree, you would have a hard time
 To capture the fruit which I sing;
The tree is so tall that no person could climb
 To the boughs where the sugar-plums swing!
But up in that tree sits a chocolate cat,
 And a gingerbread dog prowls below—
And this is the way you contrive to get at
 Those sugar-plums tempting you so:

You say but the word to that gingerbread dog
 And he barks with such terrible zest
That the chocolate cat is at once all agog,
 As her swelling proportions attest.
And the chocolate cat goes cavorting around
 From this leafy limb unto that,
And the sugar-plums tumble, of course, to the ground—
 Hurrah for that chocolate cat!

There are marshmallows, gumdrops, and peppermint canes,
 With stripings of scarlet or gold,
And you carry away of the treasure that rains
 As much as your apron can hold!
So come, little child, cuddle closer to me
 In your dainty white nightcap and gown,
And I'll rock you away to that Sugar-Plum Tree
 In the garden of Shut-Eye Town.

127

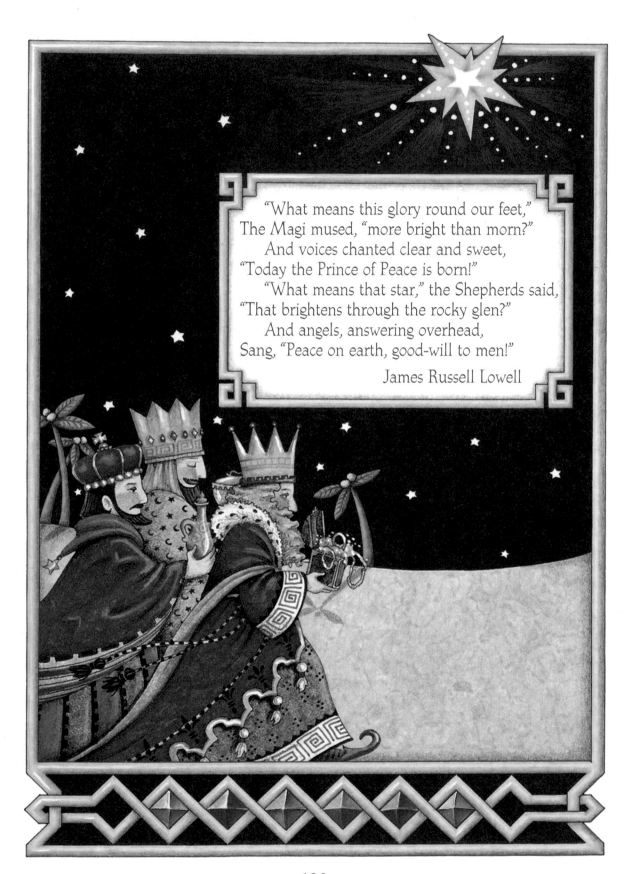

"What means this glory round our feet,"
The Magi mused, "more bright than morn?"
And voices chanted clear and sweet,
"Today the Prince of Peace is born!"
"What means that star," the Shepherds said,
"That brightens through the rocky glen?"
And angels, answering overhead,
Sang, "Peace on earth, good-will to men!"

James Russell Lowell

Jolly Old St. Nicholas

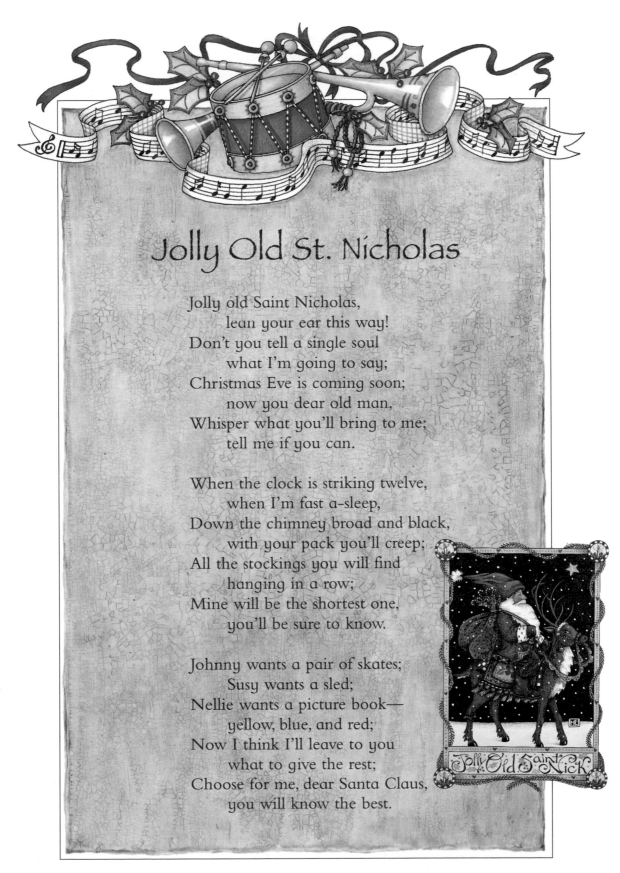

Jolly old Saint Nicholas,
 lean your ear this way!
Don't you tell a single soul
 what I'm going to say;
Christmas Eve is coming soon;
 now you dear old man,
Whisper what you'll bring to me;
 tell me if you can.

When the clock is striking twelve,
 when I'm fast a-sleep,
Down the chimney broad and black,
 with your pack you'll creep;
All the stockings you will find
 hanging in a row;
Mine will be the shortest one,
 you'll be sure to know.

Johnny wants a pair of skates;
 Susy wants a sled;
Nellie wants a picture book—
 yellow, blue, and red;
Now I think I'll leave to you
 what to give the rest;
Choose for me, dear Santa Claus,
 you will know the best.

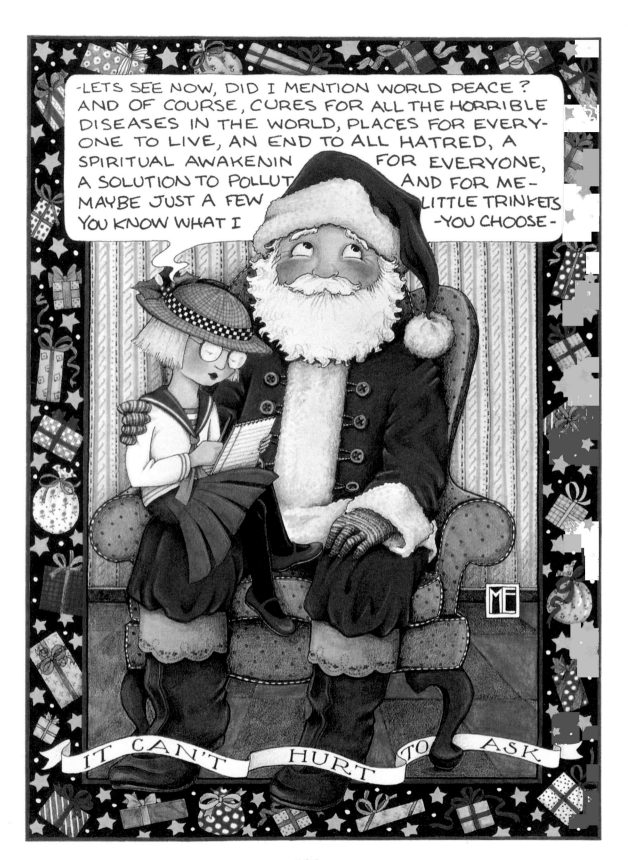

130

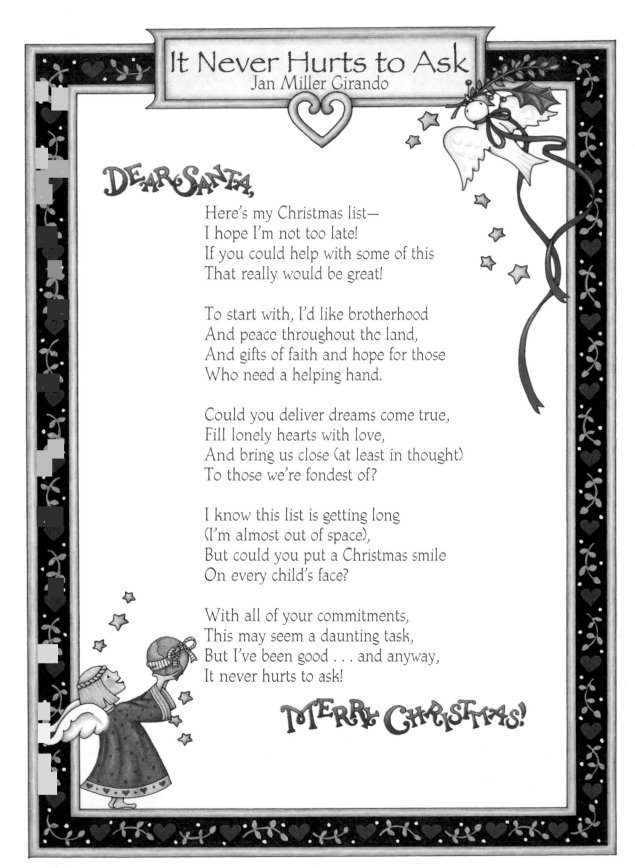

It Never Hurts to Ask
Jan Miller Girando

DEAR SANTA,

Here's my Christmas list—
I hope I'm not too late!
If you could help with some of this
That really would be great!

To start with, I'd like brotherhood
And peace throughout the land,
And gifts of faith and hope for those
Who need a helping hand.

Could you deliver dreams come true,
Fill lonely hearts with love,
And bring us close (at least in thought)
To those we're fondest of?

I know this list is getting long
(I'm almost out of space),
But could you put a Christmas smile
On every child's face?

With all of your commitments,
This may seem a daunting task,
But I've been good . . . and anyway,
It never hurts to ask!

MERRY CHRISTMAS!

Christmas

Leonard Clark

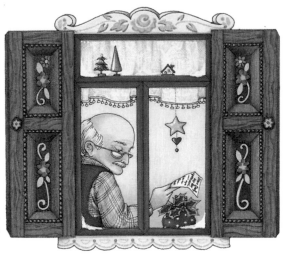

I had almost forgotten
 the singing in the streets,
Snow piled up by the houses, drifting
Underneath the door
 into the warm room,
Firelight, lamplight, the little lame cat
Dreaming in soft sleep on the hearth,
 mother dozing,
Waiting for Christmas to come,
 the boys and me
Trudging over blanket fields
 waving lanterns to the sky.
I had almost forgotten the smell,
 the feel of it all,
The coming back home,
 with girls laughing like stars.
Their cheeks, holly berries,
 me kissing one,
Silent-tongued, soberly,
 by the long church wall;

Then back to the kitchen table,
 supper on the white cloth,
Cheese, bread,
 the home-made wine;
Symbols of the night's joy, a holy feast.
And I wonder now, years gone,
 mother gone,
The boys and girls scattered,
 drifted away with the snowflakes,
Lamplight done, firelight over,
If the sounds of our singing
 in the streets are still there,
Those old tunes, still praising;
And now, a life-time of Decembers
 away from it all,
 A branch of remembering
 holly spears my cheeks,
 And I think it may be so;
 Yes, I believe it may be so.

A Child's Christmas Eve Dream

Ethel Van Deusen Humiston

Last night I had a lovely dream,
But strange as it could be,
For on the hill beside our house
Stood a great Christmas tree.

It glowed with lighted candles,
High at the top, a star,
And 'round it, dancing in a ring,
Children from lands afar.

Turkish lads in tassled fez,
Tots from France and Greece and Poland,
Laughing as the children do
In the safety of a free land.

There were polite, little English girls,
Swiss boys with funny skis,
Dutch children in queer wooden shoes,
Joined hands with shy Chinese.

Perhaps my dream's a prophecy
Of Christmases to be,
When little children everywhere
Can sing because they're free.

I surely wish with all my heart,
This day of Jesus' birth,
That peace and love and happiness
Soon cover all the earth.

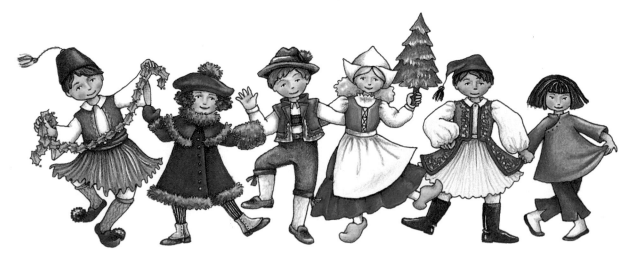

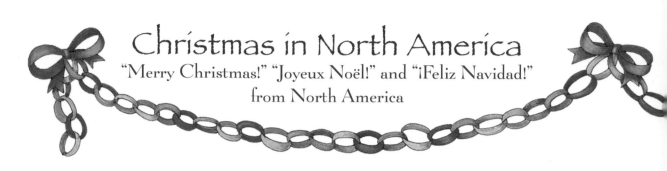

Christmas in North America
"Merry Christmas!" "Joyeux Noël!" and "¡Feliz Navidad!"
from North America

The many different ways in which Christmas in North America is celebrated reflects the rich cultural histories of the people who live here. As a result our traditions are as diverse as we are. Despite these differences, or maybe because of them, we are united by the many public, institutional, and commercial traditions that mark the season.

Some public traditions are large-scale spectacles, such as the lighting of the Christmas tree in Rockefeller Center in New York City, the decorated window scenes at Marshall Field's department store in Chicago, or the Santa Claus parade in Toronto. Some are more personal, such as the way people decorate their homes and gardens. One would be hard-pressed to find a neighborhood where a few homes weren't adorned with at least a wreath. In the southwest, you'll often find the lanterns made from paper sacks called luminaria or *farolitos*. And nothing cheers a long winter night like a home festively glowing or blinking with lights.

The poinsettia plant, another popular decoration, is called the "flower of the holy night" in Mexico. Its brilliant leaves are one of the more beautiful displays of red one is likely to see during the holiday season.

Of course, when it comes to red, it's almost impossible to get through the season without seeing Santa Claus at least once—whether he's

attending to a long line of children in a mall, or ringing up support for charity.

Bells and Christmas carols are as ubiquitous to our ears as lights and Santa are to our eyes. The soundtrack to Christmas in North America is the jangle of a sleigh bell and the lilting melodies of the Christmas classics, which you will hear just about anywhere regardless of what you're doing; if you have a radio or TV on, if you're at home,

at work, or out shopping, the sounds of Christmas will accompany you.

One of the most popular ways to celebrate Christmas as a community is to attend a seasonal performance. It seems that just about every church, school, amateur or professional

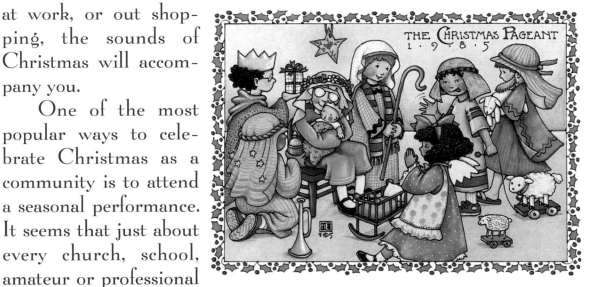

theater stages a production of the Christmas pageant, Charles Dickens's *A Christmas Carol,* or Tchaikovsky's *The Nutcracker.* And if you don't go out to see them, you will probably have several opportunities to catch them at home on TV, in addition to some of the uniquely American Christmas TV programs, such as the films *It's a Wonderful Life* and *Miracle on 34th Street,* and the animated classics *The Grinch Who Stole Christmas, Frosty the Snowman,* and *Rudolph, the Red-Nosed Reindeer.*

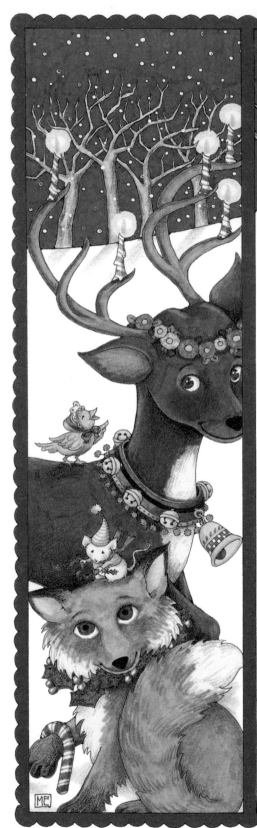

All Things Bright and Beautiful

Cecil Frances Alexander

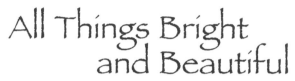

All things bright and beautiful,
 All creatures great and small,
All things wise and wonderful,
 The Lord God made them all.

Each little flower that opens,
 Each little bird that sings,
He made their glowing colours,
 He made their tiny wings.

The rich man in his castle,
 The poor man at his gate,
God made them, high or lowly,
 And ordered their estate.

The purple-headed mountain,
 The river running by,
The sunset, and the morning,
 That brightens up the sky;

The cold wind in the winter,
 The pleasant summer sun,
The ripe fruits in the garden,
 He made them every one.

The tall trees in the greenwood,
 The meadows where we play,
The rushes by the water,
 We gather every day;—

He gave us eyes to see them,
 And lips that we might tell,
How great is God Almighty,
 Who has made all things well.

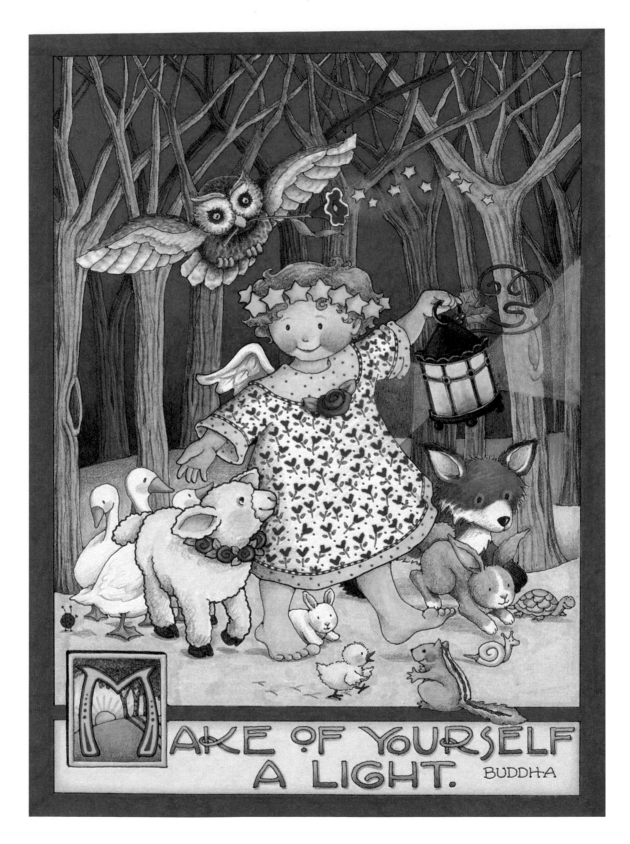

MAKE OF YOURSELF
A LIGHT. BUDDHA

Let There Be Peace on Earth
(Let it Begin with Me)
Sy Miller and Jill Jackson

et there be peace on earth
And let it begin with me.
Let there be peace on earth
The peace that was meant to be.

With God as our Father
Brothers all are we.
Let me walk with my brother
In perfect harmony.

Let peace begin with me
Let this be the moment now.

With ev'ry step I take
Let this be my solemn vow;
To take each moment and live
Each moment in peace eternally.
Let there be peace on earth
and let it begin with me.

I like days
when feathers are snowing,
and all the eaves
have petticoats showing,
and the air is cold,
and the wires are humming,
but you feel all warm . . .
with Christmas coming!

 Aileen Fisher

O the snow, the beautiful snow,
Filling the sky and the earth below.
Over the house-tops, over the street,
Over the heads of the people you meet,
 Dancing,
 Flirting,
 Skimming along,
Beautiful snow, it can do nothing wrong.

 John Whittaker Watson

It's Beginning to Look Like Christmas

Meredith Willson

It's beginning to look a lot like Christmas
Ev'rywhere you go;
Take a look in the five-and-ten,
 glistening once again
With candy canes and silver lanes aglow.

It's beginning to look a lot like Christmas,
Toys in ev'ry store,
But the prettiest sight to see is the holly that will be
On your own front door.

A pair of hopalong boots and a pistol that shoots
Is the wish of Barney and Ben;
Dolls that will talk and will go for a walk
Is the hope of Janice and Jen;
And Mom and Dad can hardly wait
 for school to start again.

It's beginning to look a lot like Christmas
Ev'rywhere you go;
There's a tree in the Grand Hotel,
 one in the park as well,
The sturdy kind that doesn't mind the snow.

It's beginning to look a lot like Christmas;
Soon the bells will start,
And the thing that will make them ring
 is the carol that you sing
Right within your heart.

he merry Christmas, with its generous boards,
Its fire-lit hearths, and gifts and blazing trees,
Its pleasant voices uttering gentle words,
Its genial mirth, attuned to sweet accords,
Its holiest memories!
The fairest season of the passing year—
The merry, merry Christmas time is here.

George Arnold

Blessed is the season which engages the whole world
in a conspiracy of love.

Hamilton Wright Mabie

hristmas is here,
Merry old Christmas,
Gift-bearing, heart-touching,
Joy-bringing Christmas,
Day of grand memories,
King of the year!

Washington Irving

142

Holly and Holiness
 Come well together,
Christ-Child and Santa Claus
 Share the white weather;
Plums in plum pudding and
 Turkey with dressing,
Choirs singing Carols—
 All have his blessing.

 Ralph W. Seager

appy, happy Christmas, that can win us back
to the delusions of our childhood days, recall to
the old man the pleasures of his youth, and
transport the traveler back to his own fireside and
quiet home!

 Charles Dickens

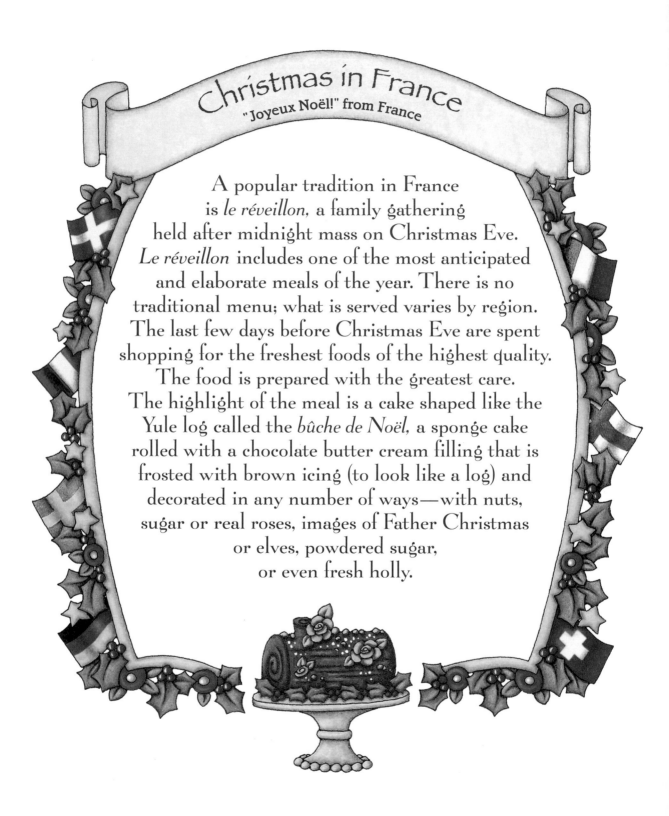

Christmas in France
"Joyeux Noël!" from France

A popular tradition in France
is *le réveillon,* a family gathering
held after midnight mass on Christmas Eve.
Le réveillon includes one of the most anticipated
and elaborate meals of the year. There is no
traditional menu; what is served varies by region.
The last few days before Christmas Eve are spent
shopping for the freshest foods of the highest quality.
The food is prepared with the greatest care.
The highlight of the meal is a cake shaped like the
Yule log called the *bûche de Noël,* a sponge cake
rolled with a chocolate butter cream filling that is
frosted with brown icing (to look like a log) and
decorated in any number of ways—with nuts,
sugar or real roses, images of Father Christmas
or elves, powdered sugar,
or even fresh holly.

The Lamb
William Blake

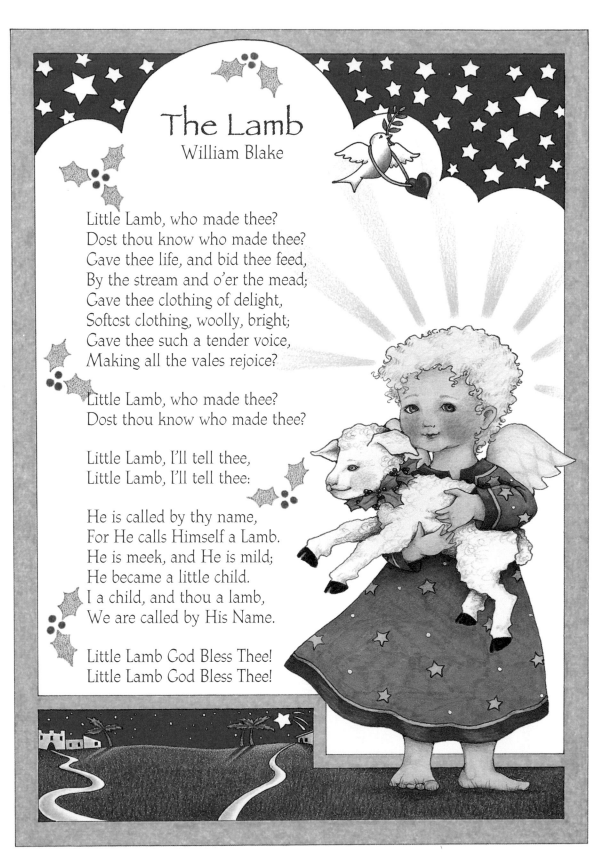

Little Lamb, who made thee?
Dost thou know who made thee?
Gave thee life, and bid thee feed,
By the stream and o'er the mead;
Gave thee clothing of delight,
Softest clothing, woolly, bright;
Gave thee such a tender voice,
Making all the vales rejoice?

Little Lamb, who made thee?
Dost thou know who made thee?

Little Lamb, I'll tell thee,
Little Lamb, I'll tell thee:

He is called by thy name,
For He calls Himself a Lamb.
He is meek, and He is mild;
He became a little child.
I a child, and thou a lamb,
We are called by His Name.

Little Lamb God Bless Thee!
Little Lamb God Bless Thee!

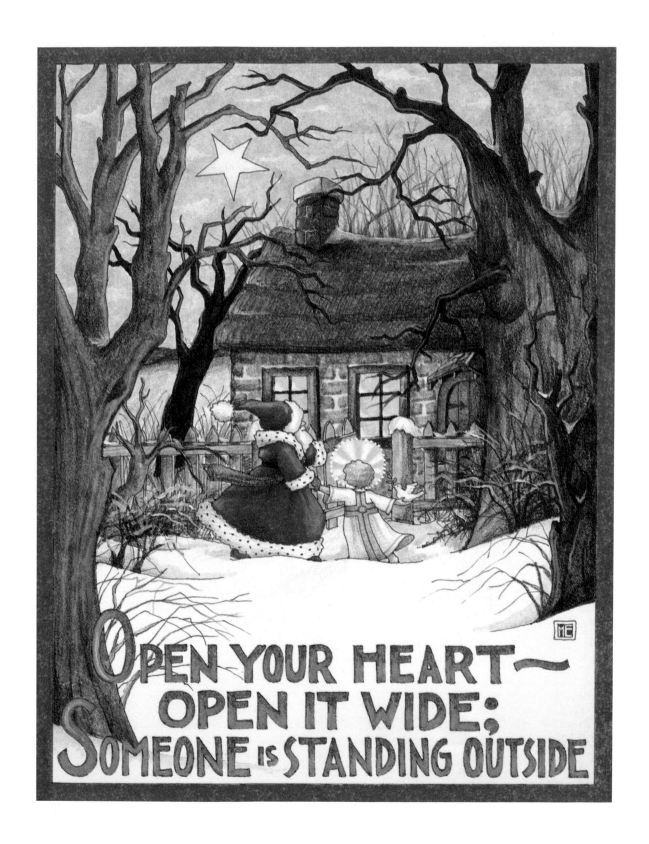

OPEN YOUR HEART —
OPEN IT WIDE;
SOMEONE IS STANDING OUTSIDE

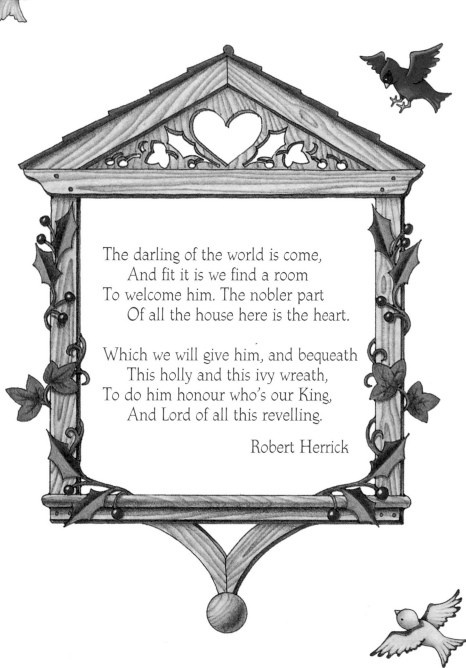

The darling of the world is come,
 And fit it is we find a room
To welcome him. The nobler part
 Of all the house here is the heart.

Which we will give him, and bequeath
 This holly and this ivy wreath,
To do him honour who's our King,
 And Lord of all this revelling.

 Robert Herrick

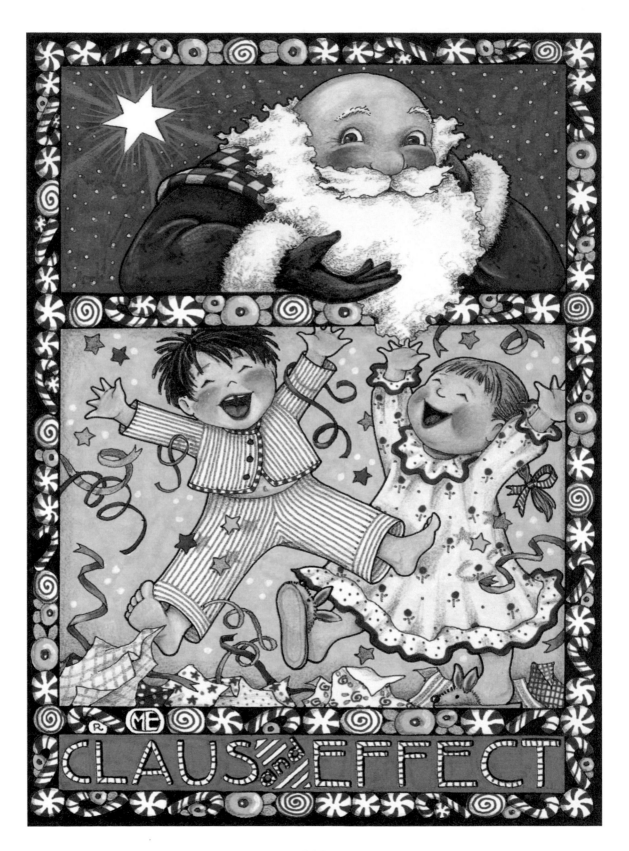

CLAUS and EFFECT

Here Comes Santa Claus

Gene Autry and Oakley Haldeman

Here comes Santa Claus,
 here comes Santa Claus
Right down Santa Claus Lane.
Vixen and Blitzen and all his reindeer
 are pulling on the rein.
Bells are ringing, children singing;
All is merry and bright.
Hang your stockings and say your pray'rs,
'Cause Santa Claus comes tonight.

Here comes Santa Claus,
 here comes Santa Claus
Right down Santa Claus Lane.
He's got a bag that is filled with toys
 for the girls and boys again.
Hear those sleigh bells jingle jangle,
What a beautiful sight.
Jump in bed, cover up your head,
'Cause Santa Claus comes tonight.

Here comes Santa Claus,
 here comes Santa Claus
Right down Santa Claus Lane.
He doesn't care if you're rich or poor
 for he loves you just the same.
Santa knows that we're God's children;
That makes ev'rything right.
Fill your hearts with a Christmas cheer,
'Cause Santa Claus comes tonight.

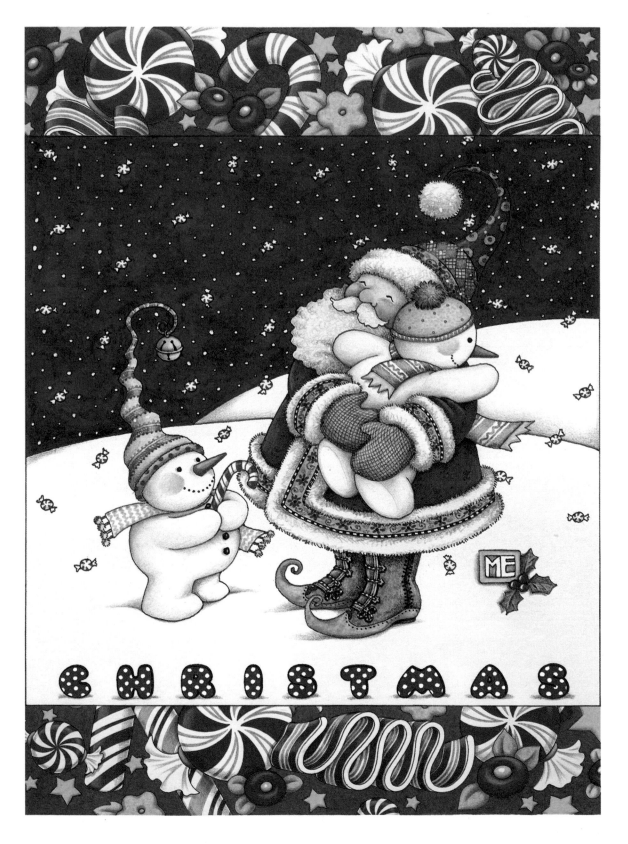

CHRISTMAS

Snow lay on the croft and river-bank in undulations softer than the limbs of infancy; it lay with the neatliest finished border of every sloping roof, making the dark red gables stand out with a new depth of colour; it weighed heavily on the laurels and fir-trees, till it fell from them with a shuddering sound . . . there was no gleam, no shadow, for the heavens, too, were one still, pale cloud—no sound or motion in anything but the dark river that flowed and moaned like an unresting sorrow. But old Christmas smiled as he laid this cruel-seeming spell on the out-door world, for he meant to light up home with a new brightness, to deepen all the richness of in-door colour, and give a keener edge of delight to warm fragrance of food; he meant to prepare a sweet imprisonment that would strengthen the primitive fellowship of kindred, and make the sunshine of familiar human faces as welcome as the hidden day-star.

George Eliot

Acknowledgments

The publisher gratefully acknowledges permission to reprint the following:

page xi, "Believe" by Jan Miller Girando. Copyright © 1993 by Mary Engelbreit Ink.

page 26, excerpt from *Quite Early One Morning,* by Dylan Thomas. Copyright © 1954 by New Directions Publishing Corp. Reprinted by permission of New Directions Publishing Corp. and David Higham Associates Ltd.

page 27, excerpt from "Home for Christmas," by Elizabeth Bowen. Courtesy Mademoiselle. Copyright © 1955 (renewed 1983) by the Condé Nast Publications, Inc.

page 48, "The Substitute Reindeer" by Mrs. Roy L. Peifer. Reprinted by permission.

page 64, "little tree" by E. E. Cummings. Copyright 1925, 1953, © 1991 by the Trustees for the E. E. Cummings Trust. Copyright © 1976 by George James Firmage, from *Complete Poems: 1904–1962* by E. E. Cummings, edited by George J. Firmage. Reprinted by permission of Liveright Publishing Corporation.

page 67, "Carol of the Brown King" by Langston Hughes. From *Collected Poems* by Langston Hughes. Copyright © 1994 by the Estate of Langston Hughes. Reprinted by permission of Alfred A. Knopf, Inc.

page 73, "Have Yourself a Merry Little Christmas" by Hugh Martin and Ralph Blane. Copyright © 1943 (Renewed) Metro-Goldwyn-Mayer, Inc. Copyright © 1944 (Renewed) EMI Feist Catalog, Inc. All rights reserved. Used by permission. Warner Bros. Publications U.S., Inc., Miami, Fla. 33014.

page 75, "Don't Waste the Miracle" by Jan Miller Girando. Copyright © 1993 by Mary Engelbreit Ink.

page 79, "Santa Claus Is Comin' to Town" by Haven Gillespie and J. Fred Coots. Copyright © 1934 (Renewed) EMI Feist Catalog, Inc. Rights for Extended Renewal Term in U.S. controlled by Haven Gillespie Music and EMI Feist Catalog, Inc. All rights outside USA controlled by EMI Feist Catalog, Inc. All rights reserved. Used by permission. Warner Bros. Publications U.S., Inc., Miami, Fla. 33014.

page 84, "Jest 'Fore Christmas" by Eugene Field. Reprinted with the permission of Scribner, a Division of Simon & Schuster from *The Poems of Eugene Field* (New York: Scribner, 1938).

page 88, "Christmas Day in the Morning" by Pearl S. Buck. Reprinted by permission of Harold Ober Associates Incorporated. Copyright © 1955 by Pearl S. Buck. Renewed 1983.

Author Index

Title Index

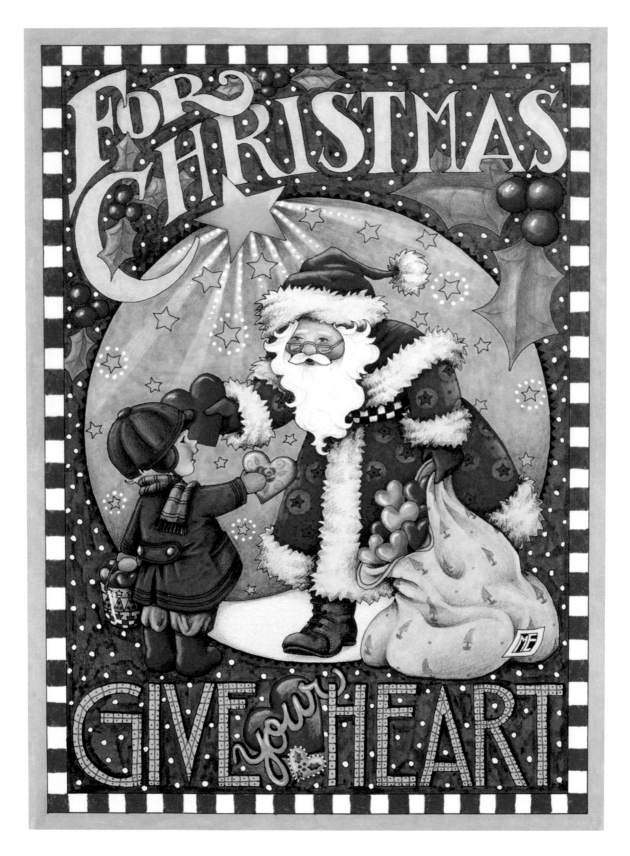

Credits

Any book that comes into this world is the result of the care and attention of a large group of people. Special thanks to the following, who worked so hard to make this book possible:

Jackie Ahlstrom
David Arnold
Stephanie Barken
Ann Feldmann
Wende Fink
Rick Hill
Becky Kanning
Jean Lowe
Elizabeth Nuelle
Marti Petty
Stephanie Raaf
Susan Reis
Jennifer Schoeneberg

To everyone at Mary Engelbreit Studios and Andrews McMeel Publishing, my heartfelt thanks for helping me realize my longstanding Christmas wish of making this book a reality.